vabi-sabi
ART WORKSHOP

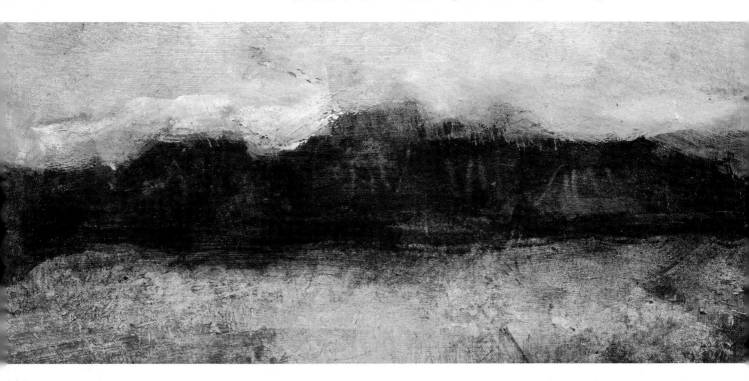

MIXED MEDIA TECHNIQUES
for EMBRACING IMPERFECTION and
CELEBRATING HAPPY ACCIDENTS

serena BARTON

NORTH LIGHT BOOKS
Cincinnati, Ohio

contents

introduction

Welcome! I'm delighted to have you join me on this wabi-sabi adventure. Together we'll create with inspiration from the world around us as well as inspiration from our feelings, memories and desires.

We all come to painting and mixed-media art via different paths. Here's my story:

I loved to draw and color as a young child. One of my first endeavors was to decorate the butcher paper "float" that my father attached to my tricycle for a children's parade when I was four. I covered the paper with mermaids, fairy queens, ballerinas and maybe even a witch. For the parade I was dressed in jeans, a sweater, a halo and wings. Being in the parade was a big deal for me. I saw my first parade at age three, and I remember crying because I wanted to be in the parade, not just watch it.

When I was a little older, acting captured my interest. Being onstage was a wonderful cure for my extreme shyness. In a play I could be anyone. As an adult I became a counselor and mother. Over the years I experimented with various crafts, such as weaving, but I was never exact enough for media where precision is important.

In 1995 I took my first trip to Italy and I was overwhelmed by the beauty I saw. The plentiful art, the crumbling surfaces of buildings, the hills of Tuscany and the canals of Venice enchanted me. I vowed then I would return to my roots and learn again to create art.

I found in my art exploration that my strength lay in expressive and intuitive work. I began with acrylic paint, moved to oil paint and fell in love with mixed media. Like many of you, I'm not content to work in just one medium. In this book I've included several of my favorites such as acrylic, re-inker, oil, plaster and encaustic. Use my techniques, media and projects as springboards to creating art with your own unique style and with the color palettes you prefer.

Whether you are a beginner, beginning again or an established artist, my message to you is the same. Experiment, enjoy, keep working, embrace accidents and mistakes and trust yourself. In this book you'll learn to delight in adding layers, subtracting elements and allowing yourself to love the process and the result!

Remember, if you're making art, you're in the parade!

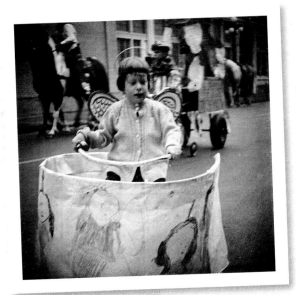

Children's Parade
Once upon a time ...

GALLERY: Desire – Encaustic on wood panel >

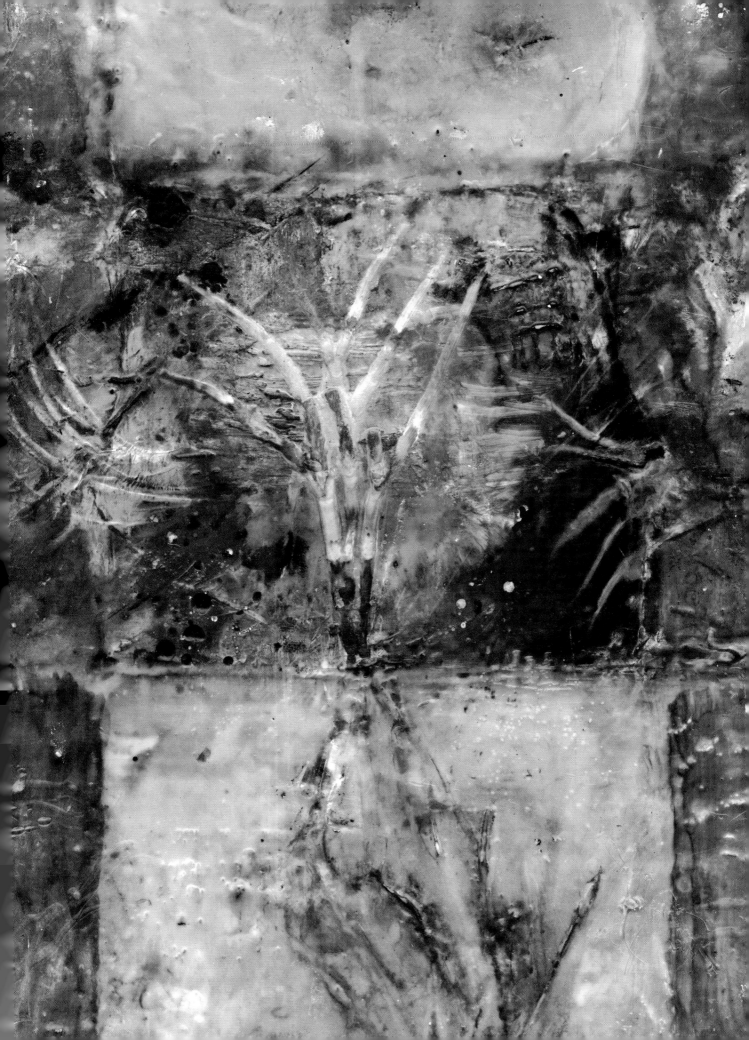

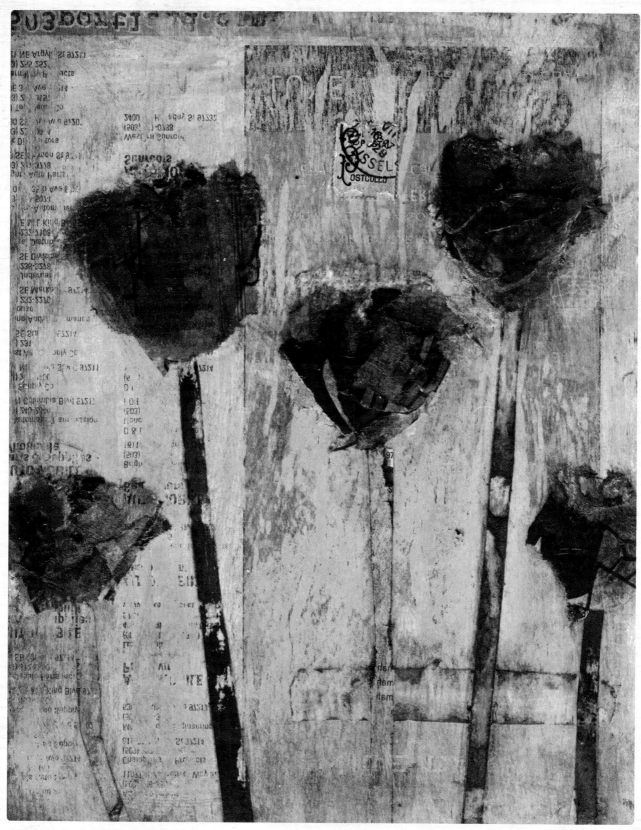

GALLERY: *Zeitgeist* – Mixed media on wood panel

finding inspiration
and beauty in the ordinary

When I first heard the term *wabi-sabi*, the sound of the words intrigued me. I set out to find out what the term meant. After finding some clues in books, photographs and, yes, the Internet, I realized the term refers to a kind of philosophy, aesthetic and feeling I had already internalized. I was excited by this realization and was inspired to begin creating paintings and mixed-media pieces that embodied my understanding of wabi-sabi.

The term *wabi-sabi* comes from two Japanese words and refers to that which is imperfect, impermanent, aged, humble and authentic. Both nature- and human-made objects may have wabi-sabi qualities. Wabi-sabi is an aesthetic that values the passing of time, the seasoning of time and the elements, the handmade and the simple. Wabi-sabi is a way of being open to emotion and acceptance. Wabi-sabi is a state of mind and a state of feeling. I find this state of being expressed in traditional haiku poetry, which can express a world of seeing, listening, smelling, tasting and feeling in the recording of a single moment.

In these pages, I'll share my understanding and inspiration with you. Together we'll explore the meaning and beauty in the ordinary objects we see every day. We'll honor the humble and the worn, the imperfect and the transitory. I'll give you tools, techniques and ideas that you can use to enter into the essence of wabi-sabi. More than anything, I'll encourage you to work from your heart. When you make wabi-sabi art, you allow the process to unfold and to envelop you in the moment. Wabi-sabi embraces serenity, joy, solitude, surprise and whatever else you may experience in the moment.

When I was in my twenties, an acquaintance who had lived in Japan told me that the Japanese ideal of beauty was a flower just past its prime, a flower beginning to turn brown at the edges of its petals. Back then, this seemed a strange idea to me, but now I understand it better.

We mixed-media artists and art lovers are drawn to objects that speak of the passage of time. We may feel bittersweet emotion as we think of those who lived before us, and we may wonder what their lives were like. We like nature in its wilder states. The wabi-sabi outlook accepts that we are all impermanent on this earth and that the most important thing in life is to be fully present in the moment. We are open to any and all of our emotions in this moment and accept them with serenity.

I am also drawn to the ideal of the handmade and the imperfections that make an object singular and meaningful. My wabi-sabi work is experimental and interactive. Rather than planning out a piece before I create it, I work with the materials and let them guide me. I make a lot of "mistakes" and have a lot of "accidents" while I'm working. And that's excellent! In this book, I will talk about the beauty of imperfection and some of the wonderful effects of unintended elements. I'll show you ways to redo pieces you've put aside, and I'll let you in on some accidental discoveries that have inspired me to use materials and techniques in new ways.

This book covers how to use your own photographs for inspiration and how to create wabi-sabi texture and color on your piece. You'll start with simple landscape compositions in acrylic and re-inker glaze and end with complex layers of mixed-media elements. Wabi-sabi can embody the "less is more" aesthetic as well as "more is more." In my work I often combine simplicity of composition with complexity of layering. The projects in this book have in common the qualities of asymmetry, a seasoned look and a sense of contemplation.

To me, wabi-sabi is like a garden that is somewhat overgrown. Maybe a secret garden that is all the sweeter for not being perfectly manicured. Wabi-sabi is subtle; it doesn't hit you over the head. It's mysterious and complex. Creating wabi-sabi work is freeing—there are no real mistakes and no wrong way to do it. The process of interacting with your materials in an open and exploratory way is as important as the finished product.

Being a visual person, I believe one of the best ways I can convey my wabi-sabi outlook is through photographs I've taken and through my artwork. Your work will be filtered through your essence as my work is filtered through mine.

The more you can remain in the process, the more you'll enjoy the pieces you make. One of the lovely paradoxes of art is that the more we play and experiment and don't try too hard to get a certain result, the more satisfied we are in the end, when we view what we've created.

tools and materials you'll want

Don't feel like you have to acquire all of these products at once. The techniques and projects in this book can be mixed and matched to use what you have. Many of the projects call for recycled materials you'll find around the house or studio. If you have some of the items on this list and a friend has others, get together to experiment.

Acrylic Gel Medium
This invaluable product comes in several finishes and in regular and soft formulas. All are suitable for projects in this book. Gel medium is used to extend and strengthen your paint film. It also makes an excellent glue and sealant for collage.

Acrylic Gesso
This is a primer coat that provides an absorbent and smooth base for your work. We'll be using white and black gesso for some of our projects. If you buy a pre-gessoed canvas you don't need to add additional gesso, although you can choose to if you want a smoother surface.

Acrylic Glaze Medium
Glaze medium is more fluid than gel medium. We'll use it to create transparent glazes of paint and re-inker color.

Acrylic Paint
This modern paint is made from pigment suspended in an acrylic polymer emulsion. In other words, it's a people-made product. You can use acrylic paints like watercolors or like oils. They are fast drying and work well in multiple layers. I recommend you use artist-grade rather than student-grade paints. The student grades have less pigment so they don't go as far.

Alcohol Inks
Like re-inkers, alcohol inks come in rich colors and can be used in a variety of ways. We'll use them to add both subtle and dramatic effects to our pieces.

Aluminum Foil

Beeswax
You'll want natural yellow or clear filtered beeswax for several projects. Beeswax comes in cakes, pellets or grains. Check the *Resources* section for sources.

Butane or Propane Torch or Embossing Gun
I usually use a torch with my encaustic work. Other artists prefer a heat or embossing gun. One project in this book requires a torch. You can use a crème brulée torch or a torch from the home improvement store. The other encaustic projects give you a choice of embossing gun or torch. If you discover you love using a torch, you can investigate other torches, such as my favorite, the Iwatani.

Camera
You'll use your camera for taking wabi-sabi inspiration photos. I use an inexpensive digital camera set at its highest resolution for most of my inspiration photos. Use whatever you have and whatever fits your present photography abilities.

Cheesecloth

Cold Wax Medium
Cold wax medium is made from beeswax, alkyd resin and mineral spirits. It is most often used for an oil paint medium, but it also makes a great final coat for pieces in any medium.

Collage Paper
These are available at art and craft stores and online. I prefer a lighter weight paper for collage so I look for that, as well as decorative napkins and specialty papers.

Colored Tissue Paper (Red and Magenta)
Again, look locally or online for art tissue paper.

Construction Paper

Damar Resin
This is a natural product from trees. It usually comes in small crystals and is used to strengthen beeswax medium.

Dress Pattern Paper
Thrift stores are an excellent source of old patterns. It doesn't matter what kind of garment the pattern is for.

Dried Tea Bags
Save those used tea bags (the kind with a staple and a tag). Let them dry out and keep them for a project in this book.

Embellishments
Embellishments are the staple of mixed-media artists. You can find metal and paper embellishments and ephemera at vintage stores, garage sales and on etsy.com and other websites. See *Hunting and Gathering Embellishments* (page 104).

Electric Skillet and Electric Griddle
We'll use these for our encaustic projects. You can buy them new or from a second-hand store. It's important that the temperature controls are in good working order so that your wax-resin mixture or encaustic paint will melt without smoking.

Encaustic Iron
Several companies make an iron especially for use with encaustic medium and paint.

Faux Finish Comb
You can pick one of these up at your local hardware store. The one I use is triangular with teeth on all sides.

Hot Sticks
Made by Enkaustikos, these are pigmented sticks of beeswax and damar resin. I melt them on an encaustic iron and then apply them to my piece.

Instant Coffee

Metal Flakes
These small flakes are great for accents. I use variegated metal flakes from Mona Lisa.

Mexican Amate Lace Marble Paper
This lovely paper is made by the Otomi Indian artisans of Mexico in accordance with a long tradition. The paper is made from the bark of the amate plant and comes in a variety of designs. We'll use the lace marble variety, which can be teased apart for stunning 3-D effects. You'll find this paper in several online shops.

Mulberry Paper
This paper is made from the bark of the mulberry tree. We'll be using this as the basis for our wabi-sabi embellished papers.

Neocolor II Crayons
These dense, highly pigmented crayons can be used alone, blended with water or smudged.

Off-White Tissue Paper
Art tissue works best. I've found that regular tissue can be too weak for some projects. Sometimes you'll get some great off-white tissue in your shopping bag.

Oil Paint
This is a slow-drying paint consisting of particles of pigment suspended in a drying oil. We'll be using oil paints with our encaustic medium for creating colored wax paint and for rubbing into the surface of an encaustic piece. As with acrylics, the artist-grade colors with their high pigment load are a better deal in the long run than student-grade oils.

Oil Pastels
These small sticks are made from pigment combined with an oil and wax binder. They work wonderfully over encaustic. They can be found at art stores and some variety stores.

Paintbrushes
I've never been one for expensive brushes for wabi-sabi work. I like nylon brushes, mostly flat, and I use a fan brush in some projects.

PanPastels
These yummy powdered pigments are packed in cake form so they can be mixed and applied like paint. We will use them for light glazes and accents.

Paper or Shop Towels
You'll be using paper towels not only for cleanup but also as collage material in one of our projects. I like the heavy paper shop towels by Scott for this purpose.

Plaster (Joint Compound)
You can purchase this building material in a powder to be mixed with water or pre-mixed in a tub. Joint compound takes longer to dry than some plaster products, so allow plenty of time for the plaster project in this book.

Pottery Scraper and Carving Tools
These tools are designed for clay work but are also used by encaustic artists. A simple beginner's carving set works fine. I use a pottery scraper with an oval- or diamond-shaped blade.

Re-inkers
Re-inkers were originally designed to refill ink in rubber-stamp pads. Throughout this book you'll find projects that require re-inkers and acrylic glaze medium to create a richly colored paint glaze.

Rubbing Alcohol

Rubber Stamps and Ink Pad
(Both alphabet and design stamps)

Silk Sari Yarn
You can buy this lovely variegated silk yarn from several online sources. It also comes in a recycled yarn variety.

Small Plastic Spray Bottle

Soy Wax
Use soy wax to clean your brushes when you use encaustic paint. Dip your brush in the melted soy wax whenever you want to change colors—then you won't need a new brush for each encaustic color. Soy wax is a vegetable product made from the oil of the soybean. It is too weak a wax to use in encaustic medium or paint except in this capacity.

Sponge
Sea sponges are especially nice for art projects, as they have variegated and natural surfaces.

Transfer Metal Leaf
This metal leaf can be transferred without the messiness of metal flakes. I use Mona Lisa Simple Leaf in gold.

Vintage Book
and Extra Vintage Pages
You can find these at thrift stores, garage sales and public library sales.

Vintage Postage Stamps
Check etsy.com, as well as other artifact and embellishment sites, for these.

Water

Wax Brushes
Nylon or other fine brushes don't work well with wax. You can pick up cheap bristle brushes at a home improvement store. No cleanup is needed. Let the wax dry on the brush and use it in a similar color next time.

Wood or Canvas Board Supports
You'll need wood panels for the encaustic projects in this book. The other projects can be done on panels, canvas boards or stretched canvas. I prefer rigid supports when I'm using mixed media.

looking for wabi-sabi
and finding it all around you

I find that looking for wabi-sabi reminds me to really pay attention to what I see and feel. The wabi-sabi search involves slowing down and observing small pieces of the world. I love going on wabi-sabi walks with my grandson or some of my young students. Children are excellent teachers for adults who live in a hurried world where it is hard to see the trees and the forest is a blur. Here are some ways to relearn how to look with wonder and openness.

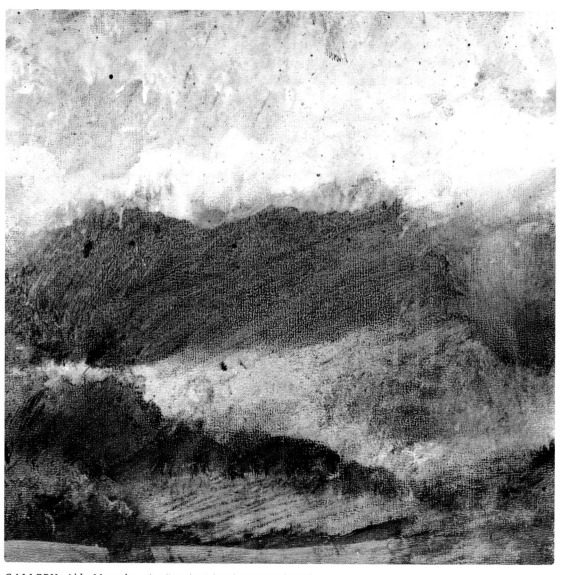

GALLERY: **Aide-Memoire** – Acrylic and re-inker glaze on wood panel

Explore your home and yard or your neighborhood. Look at both nature and human-made objects for:

- Aging
- Seasoning
- Humble form
- Simplicity
- Peeling layers
- Plant life growing through objects or pavement

Go to an old part of your town and see what glorious ruined features you can find.

Explore thrift and secondhand stores for objects that speak to you of lives well lived.

Take lots of pictures of what you find, especially close-ups. I'm not a trained photographer, but I find that with my trusty digital camera and knowledge of a few photo-editing techniques, I can take photos that inspire me to create. The photos provide a good jumping-off point for color, texture and line that I can use in my wabi-sabi work.

Besides sight, other senses may help you find wabi-sabi:

- The smell of distant wood smoke on an autumn evening
- The smell of new-mown grass that makes you momentarily long for childhood
- Fragrant flowers at twilight on a summer night
- The smell of the sea enveloping you on a deserted beach
- The sound of bamboo wind chimes at dusk
- Hearing the crashing of the surf on a foggy day on the coast
- Hearing the call of an owl while you are sleeping under the stars
- Touching the pitted surface of a clay bowl
- Stroking the wrinkled face of an elder
- Feeling the cold surface of an old metal teakettle
- The earthy taste of fresh mushrooms
- The sweet-and-sour taste of miso soup
- The taste of home-cooked brown rice and vegetables

Memory can also have a big influence on your wabi-sabi art. I will always remember the sense of peace and contentment I had when I visited my grandmother's house. She decorated with calming colors and lots of inspirational artwork. At the lower edge of her large garden was a slough. My grandfather used to take me out in his rowboat and encourage me to pretend the slough was the Mississippi River.

I remember family visits to the beach. I found lots of shell pieces and agates that seemed magical to me at the time. I find the colors of my grandmother's house and garden reappear in my artwork, as well as misty ocean and river elements. By allowing ourselves to remember, we can visit those places that filled us with wonder.

WHAT YOU'LL NEED for this chapter

Acrylic gel medium

Acrylic gesso

Acrylic glaze medium

Acrylic paint in: white, Titan Buff, Payne's Gray and your favorite colors

Cold wax medium

Distress ink pad

Paintbrushes

Paper or shop towels

Re-inkers in several shades

Rubbing alcohol

Small plastic spray bottle

Water

Wood or canvas supports

Wabi-Sabi Colors

Colors that I associate with wabi-sabi tend to be rich, muted and complex. A warm palette might contain red-browns, Buff White, yellow gold, yellow green and Ultramarine Blue. Nature's autumn colors, those of the falling leaves and decaying vegetation, may be the most wabi-sabi colors of the palette. You can create wabi-sabi pieces with a cooler palette as well. Silver, mauve, pastel yellows, cool blues, grays and black can evoke winter and also the aged look of old metal.

I often use bright colors for accents in my pieces, as they can create "sweet spots" of emphasis in a more muted pal-

ette. Other times I may start with a bright color and put transparent layers of a more muted tone over the bright one. This suggests the aged and burnishing effect of time and the elements.

During all the seasons, I enjoy taking photos that suggest wabi-sabi colors to me. I'm happy to be able to share some of these photographs with you. For each season, I have included a photo that I've taken along with a traditional haiku that evokes that particular season.

Fall

NO ONE TRAVELS

ALONG THIS WAY BUT I,

THIS AUTUMN EVENING.

~Bashō

Winter

A MOUNTAIN VILLAGE

UNDER THE PILED-UP SNOW

THE SOUND OF WATER.

~Shiki

Spring

THE LILIES!

THE STEMS, JUST AS THEY ARE

THE FLOWERS, JUST AS THEY ARE.

~Bashō

Summer

SPRING AIR—

WOVEN MOON

AND PLUM SCENT.

~Bashō

Wabi-Sabi Texture

I think of texture as something I can see and that I can imagine feeling with my hands even if I'm just looking at a photograph. Wabi-sabi texture is varied, rough, stimulating and alive. Children are often encouraged to explore texture by plunging their hands into large containers of rice, lentils, sand and clay. I find that texture is stimulating to adults as well!

I took the photos below in a walk around my neighborhood. On the way to my local coffee shop, I looked for textures that inspired me with qualities of complexity, age, contrast and depth. I'm always delighted with the many interesting textures I can find when I pay attention to what is around me.

Density
I was entranced by this web of lines and circles. I enhanced the color of this photo using the "old photo" filter in my photo-editing program.

Grate
Getting close to this grate produced a photo of a rich raised texture. I altered the photo to a sepia color in my computer to give an aged effect .

Sidewalk Crack
I found the textures and lines in this section of sidewalk so interesting in themselves that I decided to delete the color via my editing program.

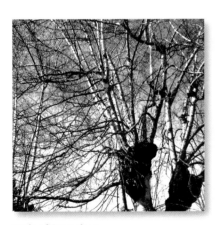

Web of Branches
 I converted this photo to black and white in order to focus on the intricate web of branches and the shapes of the tree growths at the bottom of this image. This image inspires me to create a piece with a network of cracks like in old paintings.

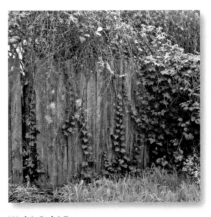

Wabi-Sabi Fence
This neglected spot at the edge of the garden contains a fascinating variety of textures. The rough aged wood, pile of straw, brambles, long grass and ivy produce a sense of peace and refuge.

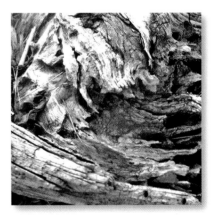

Old Tree Trunk
This image contains both swirled and sharp shapes and lines. I lowered the saturation to better focus on the texture alone.

A Wabi-Sabi Photo Gallery

Tintoretto House
Crumbling brick, peeling paint and disintegrating wood characterizes the former home of a Venetian Renaissance painter.

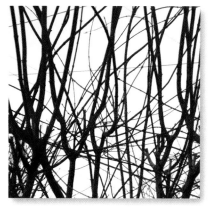

Red Branches
A tangle of trees in my neighborhood.

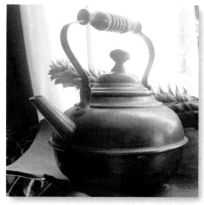

Mary's Kettle
My great-grandmother's dented teakettle sitting on a hand-built pottery stand. A monkey-puzzle pod completes the image.

Cemetario
On the cemetery island in Venice. An air of peaceful wildness—human creation intersecting with the natural world.

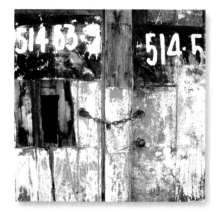

On the Street
In Oaxaca City, Mexico. A fascinating abstract created by time and neglect.

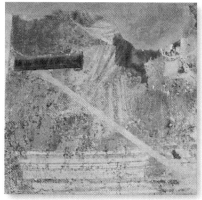

Fresco
A decaying fresco, passed daily by shoppers on one of Bologna, Italy's main streets.

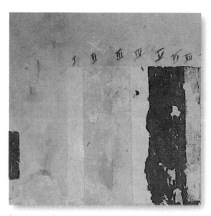

Incarnations
An art or history student may have been the one to document the layers of paint on the wall of this building belonging to the University of Bologna. The building dates back to medieval times and was originally a monastery.

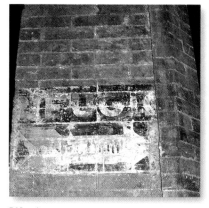

Rifugio
A World War II bomb shelter sign in Bologna takes us back to a time when, for most people of the world, hope was fighting with dread.

Mystery House
A deserted house on the coast—weathered and mysterious.

 visit www.createmixedmedia.com/wabi-sabi for extras

Use Your Photo for Inspiration

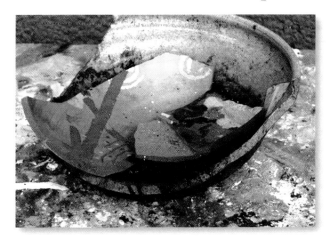

I took this picture on my first wabi-sabi walk around the outside of my house. On my back porch, two broken pots sat atop a paint-stained table. The burnt orange stucco area at the top of the picture is part of an exterior wall of the house.

The pot directly on top of the table has some potting soil in it. Or maybe it's just plain dirt! Really, this is a picture of junk. Or is it? There's still beauty in the shards of handmade pottery and in the glistening colors of what used to be my paint table.

To me the way the colors, shapes and designs are juxtaposed gives me wabi-sabi inspiration. The colors of this photo have inspired several of my autumn pieces. I had put this arrangement together before I'd ever heard the term *wabi-sabi*. But I knew the arrangement spoke to me of accidental beauty arising from imperfection and even decay.

Take your own photo of an arrangement that inspires you. Choose a color scheme from the arrangement. From the photo above I chose terra-cotta red, turquoise and Burnt Umber for one of the pieces below, *Between*, and the shape for the other piece, *Chalice*. Which colors and shapes might you choose?

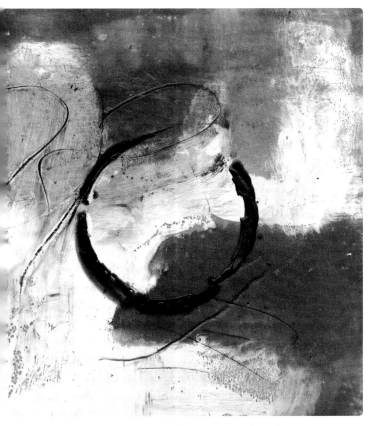

GALLERY: Between – Encaustic on wood panel

This piece borrows colors and an aged look from the pottery shards photograph.

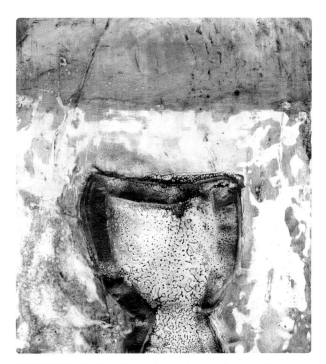

GALLERY: Chalice – Encaustic and mixed media on wood panel

In this piece I borrowed the roundness of the broken bowls, creating the top part of the chalice.

Use Your Photo for Setting a Mood

I took this photo on the cemetery island of Venice, again, long before I knew the term wabi-sabi. To me, this picture speaks of the cycle of life and death and the changes that are wrought by time. The tomb in the foreground has started to crumble, the brick of the building is discolored and the gravel is unevenly distributed. The old-fashioned broom adds a piquant note to this picture of change in progress. Even though the picture was taken in the cemetery, the sun seems warm and the overall feeling is one of peace and acceptance.

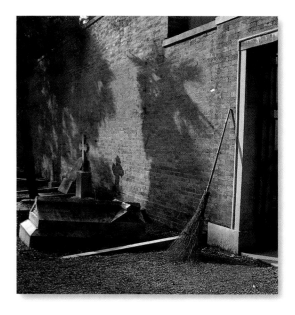

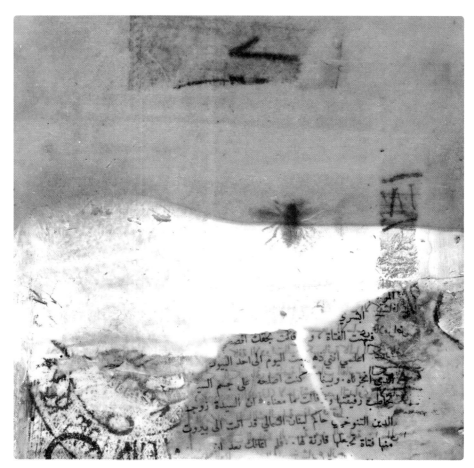

GALLERY: **Little Fly** – Encaustic and collage on wood panel

This piece uses colors from the photo above and contains a similar sense of peace amid endings.

Inspiration Haiku

In addition to getting inspiration from images and from what we see around us, we can also get inspiration from poems written by the haiku masters of Japan. These exquisite writings have taught me much about wabi-sabi. In the original Japanese, each haiku uses only seventeen syllables to capture a moment in a way that engages all of our senses and emotions.

A haiku pinpoints the emotions and mind state of the writer in a given moment. In just three lines, a haiku can make us feel as though we are in the experience with the writer. Haiku can be funny, sad, nostalgic, brisk and all of these at once. Reading a haiku and sitting with the feelings and mental images the poem evokes can be a vital starting point to creating a piece.

Try reading one of the traditional haiku in this book or look online for haiku. Find one that speaks to you and think of it as you create a piece. The haiku and your work can become a dialogue of expressiveness.

Here's a haiku I recently contemplated:

IT'S COLD—AND I WAIT
FOR SOMEONE TO SHELTER ME
AND TAKE ME FROM HERE.
~Bashō

Here's the piece I made in response:

GALLERY: It's Cold Here – Acrylic and paper on wood panel

Mixing Acrylics

Now that we've explored photos as sources of inspiration, we're getting ready to start creating our art. For the piece we'll make in this chapter, I'm going to use the autumn colors found in my inspiration photograph of pottery shards on a paint-stained table (see page 15). There are a couple of ways I can do this. I can use paints that are already just the colors I want, or I can mix my own colors. For this piece I'll go for some transparent colors, such as Nickel Azo Gold, Red Iron Oxide and Green Gold. Other transparent colors I suggest are Ultramarine Blue, Payne's Gray, Viridian or Pthalo Green and Burnt Umber. I'll also choose some opaque colors, such as Titan Buff, Titanium White, Yellow Ochre, Raw Umber and a strong red. Using both transparent and opaque colors creates vibrant contrasts.

If I don't have the colors I want, I mix them as I go. Here are some examples of colors you can mix for wabi-sabi art. (First check the back of the paint tube or jar to see if it is transparent, opaque, semitransparent or semi-opaque.)

Add white
to transparent colors for brightness and/or covering power.

Make wabi-sabi green
by mixing yellow and Payne's Gray.

Make wabi-sabi gold
with yellow, red and Burnt Umber.

Make a rusty red
with bright red and Burnt Umber.

Add buff to colors
to make them more subtle and opaque.

Creating Visual Texture

Visual texture refers to an illusion of texture. Your surface may be smooth all over but you can give the appearance of texture by using the techniques below. I love to experiment and see what happens when I blot layers and then use my wet paper towel to go over another area. Mixing it up like this adds to the aged and imperfect wabi-sabi effect.

Drybrushing is another great method for adding texture and for bringing your piece together. This technique is done just the way it sounds. Take a dry brush and put the color on your support with a scrubbing stroke. Your previous layer will be covered unevenly, an effect that adds the look of a textured surface. If you have, for example, a large blue area and a large green area, drybrush a bit of the blue over the green and vice versa. This unifies the piece while retaining separate areas.

Blot layers with a paper or shop towel.

Rub in color with a paper or shop towel.

Drybrush over a previous layer.

wabi-sabi wisdom

No matter what method you choose to add visual texture, vary the pattern and amount of the texture you use on the piece. It's important for the eye to be able to rest in less-textured areas and to be stimulated in more-textured areas.

USING RUBBING ALCOHOL

Plain old rubbing alcohol can add a lot of interest to your work. You'll get some interesting effects where the alcohol has moved the paint around or has removed some of it. If you have taken off more than you wanted to, just go over the sprayed areas with more of the original color.

1 Put the alcohol in a spray bottle and spritz very lightly on the surface of your piece.

2 Blot gently before the alcohol dries.

USING WATER

I became enamored with this technique following a happy accident. I once carried a slightly wet piece from my detached studio into the house—in the rain! The raindrops created a highly interesting surface. Now I often add a few water drops on purpose. Doing so creates subtle surface texture and can also suggest the effects of a landscape seen through a window or through a mist.

1 Drop water onto the piece using your fingers.

2 Blot the water gently.

Finishing Touches

To add an aged look, bring the eye more closely into the picture and make the piece appear more complete, try these finishing touches.

Use a distress ink pad to go around the edges of the piece.

Add a little ink from the pad to the corners of the piece. This produces a sense of being closer to the piece.

Sealing Your Pieces

Trust me, you want to wait until your piece is thoroughly dry before you even think about sealing it. Once it is dry, you can consider a few options. Sealing helps protect your piece, and the methods below will both do that. Beyond that it's up to you what kind of effect you want. I find that some pieces look good with a shiny surface. For these I use acrylic gel gloss medium. Others seem to call for a matte look, so I use acrylic gel matte medium. My favorite sealant, though, is cold wax medium.

Cold wax medium is designed for use with oil paint to create impasto (raised paint) and to provide a more matte finish than other oil painting mediums. The great news is that acrylic and mixed-media artists can also use cold wax over their work. It gives a beautiful, organic, satiny look to the piece and can even make the colors richer.

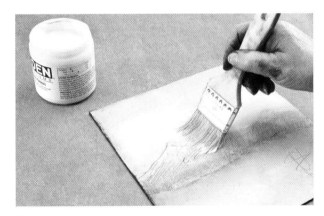

Option 1
With an acrylic gel medium

wabi-sabi wisdom

For interesting texture, you can add fine-grained sand or ground tea to your acrylic or cold wax sealant before you brush it on your piece.

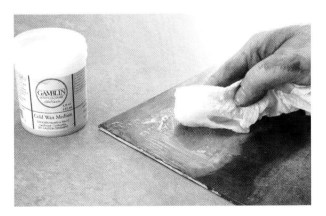

Option 2
With a cold wax medium

The Landscape Format

The landscape format is the simplest composition for you to start with. Its simplicity doesn't mean that it is a lesser composition form, however. Lots of artists have created masterpieces with this format. You may do the same! A landscape format means that your artwork consists of two or more horizontal areas. You can suggest a real landscape or you can work more abstractly. Lots of times I've started out with what I thought was an abstract in a landscape format only to find that my mind creates a picture that represents aspects of a real landscape. Landscape pieces don't have to be done in the traditional landscape style with width greater than height. You can also use a square support or one with a height greater than its width. Creating a basic landscape is a great way to focus your experiments on colors, color mixtures, paints and re-inkers and other techniques covered in this chapter.

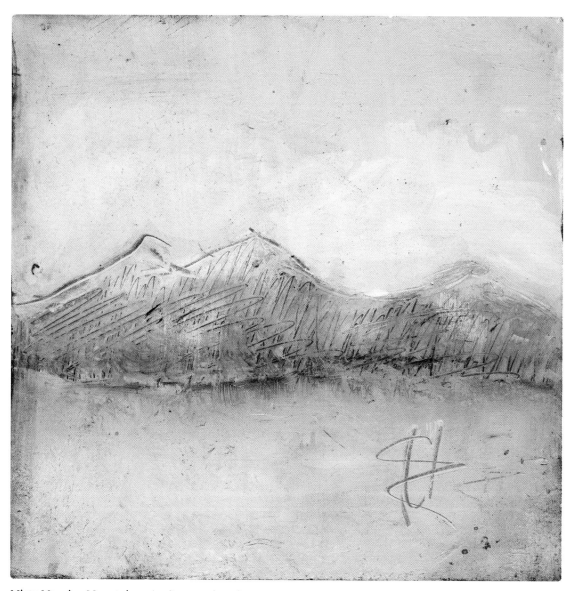

Misty Morning Mountains Acrylic on wood panel

1 Starting with a pre-gessoed wood panel, put down a layer of Nickel Azo Gold or another gold color mixed with Titan Buff. Cover the whole piece.

2 Put down a layer of Ultramarine Blue. Pat gently with a paper towel or rag.

3 When the layer of Ultramarine is dry, add a layer of Viridian over the blue, in the shape of mountains. Pat this layer gently with a paper towel or rag.

4 Mix a bright red with a little crimson. Add water or glaze medium to brush the red mixture over the mountain areas. Move a bit of the red into the Titan Buff area with your brush.

5 Mix Titan Buff with a bit of white. Using a dry brush, work this into the area over the mountains. Make this area uneven in texture and color and bring it down into the mountain area.

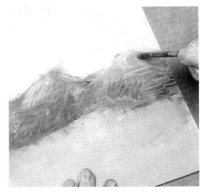

6 With the handle of a paintbrush, incise into the mountain-shaped layers of paint. Add a small design in the lower right corner using the same method.

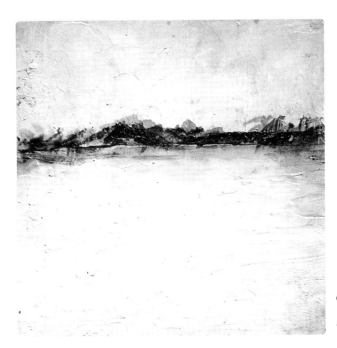

A CLUSTER OF SUMMER TREES,

A BIT OF THE SEA,

A PALE EVENING MOON.

~*Kobori Enshū*

GALLERY: Ghost River – Acrylic on wood panel

A simple composition can carry a lot of interest and meaning.

Painting with Re-Inkers

I love using re-inkers mixed with acrylic glaze medium as my paint in wabi-sabi work. I discovered re-inkers several years ago and was amazed at the rich colors they provided. I immediately began painting with them on small wood panels. I discovered after a while that the re-inkers tended to sink into the wood and that the colors didn't stay vivid. After I recovered from my disappointment, I came up with the idea of mixing the re-inker color with acrylic glaze medium to make the paint film stronger. It worked! The combination of the medium and re-inker produced gorgeous paint layers that didn't fade. From now on when I refer to re-inker glaze, that's my shorthand for re-inkers mixed with acrylic glaze medium. You'll find that the re-inker colors are so rich that you need to use less than you might think when you make your re-inker glaze. Experiment with earth colors, bright colors and light re-inker colors. A spot of vivid color can bring an earth-toned piece to life, while a contrasting light color can give a subtle glow when applied over a light area of your piece.

In the following project you'll create an atmospheric piece reminiscent of an old oil painting. Grab your favorite re-inker colors, glaze medium and brushes—and go!

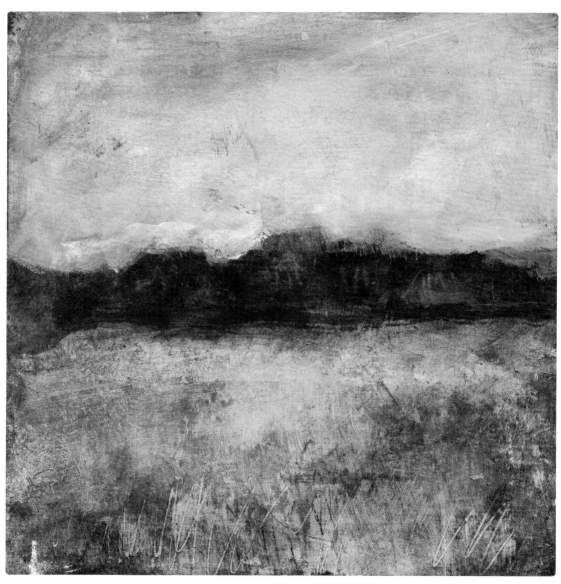

Field at Night – Re-inker glaze on wood panel

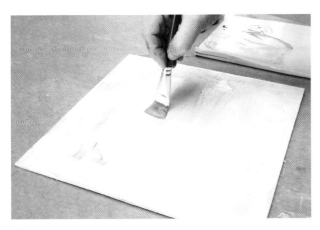

1 Start with a pre-gessoed canvas or board. Paint the surface with a layer of Slate re-inker mixed with acrylic glaze medium. Blot with a paper towel.

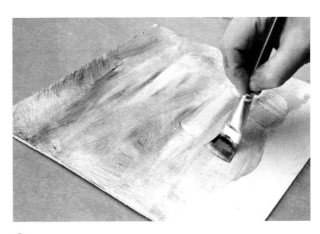

2 When the Slate layer is dry, add a layer of Denim re-inker mixed with acrylic glaze over the slate. Blot gently.

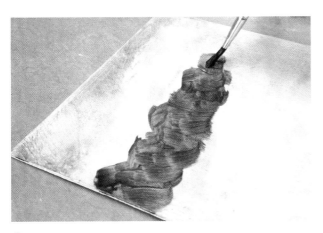

3 Toward the center of the piece, brush on Rust re-inker and glaze medium to resemble a grove of trees.

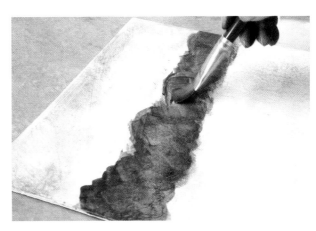

4 After the previous layers are dry, brush on a glaze of Lettuce re-inker.

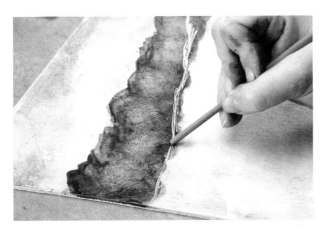

5 Incise into the bottom of this area with a narrow brush handle.

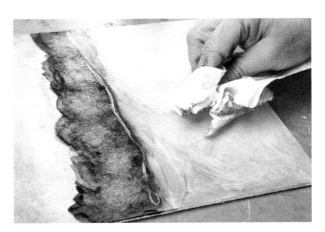

6 Below the incised area, brush on a layer of Butterscotch re-inker glaze and wipe with a towel to remove excess and add a bit of texture.

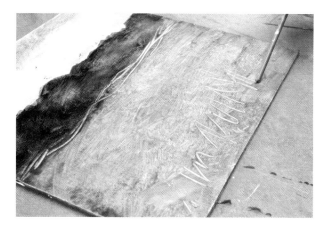

7 Incise vertical lines in a loose zigzag pattern over the bottom of the piece.

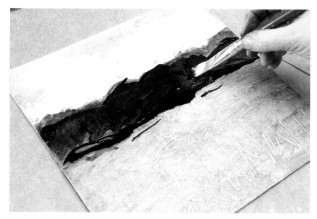

8 Brush on and blot a bit of the Slate re-inker in various places over the tree area.

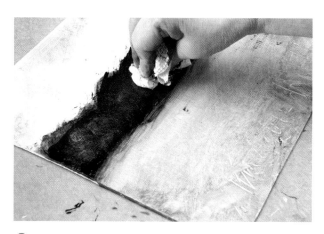

9 Brush a narrow band of Plum re-inker glaze below the incised tree area. Blot a small amount of this color onto the area below.

10 Mix a little Denim re-inker with a little gesso and paint over the tree area on the left side of the canvas.

11 Add Slate re-inker mixture to the bottom corners of the piece. Gently blot a small amount of each re-inker color in random areas over the piece to create an aged look.

wabi-sabi wisdom

- Remember to use the glaze medium with the re-inker color.

- Let each layer dry before you add the next one.

- It's fine to mix re-inker colors to create custom colors.

- Start with a light-colored layer; you can always make it darker.

- Alternating warm and cool colors yields a rich effect.

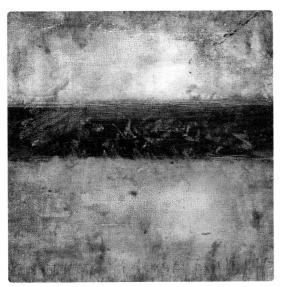

EVENING BREEZE …

WATER LAPS THE LEGS

OF THE BLUE HERON.

~Buson

GALLERY: **No More to Be Said** – Re-inker glaze on wood panel

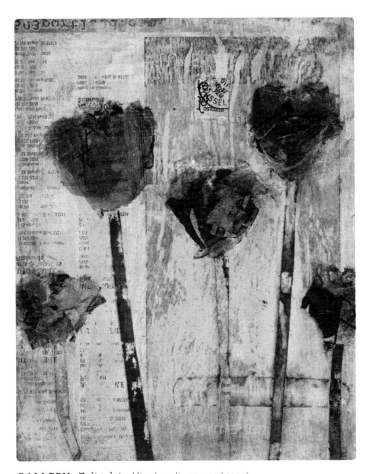

GALLERY: **Zeitgeist** – Mixed media on wood panel

I painted vibrant re-inkers and glaze medium over this layered collage.
Notice the ethereal transparency of the re-inker glaze.

Acrylic Paint and Re-Inkers

Re-inker glaze works wonderfully with liquid or regular acrylic paint. I often add buff or white acrylic paint to a re-inker color used in one area of the piece in order to make a stronger contrast with the part of the piece done only in re-inker glaze. You can also add re-inker and glaze over an area painted with acrylic paint. Adding white to a re-inker color brightens the color and makes it more opaque. In this project I have evoked a cloudy day at the coast, with the hint of a ship at the horizon line. I've also used several aging and blotting techniques to instill a feeling of mystery.

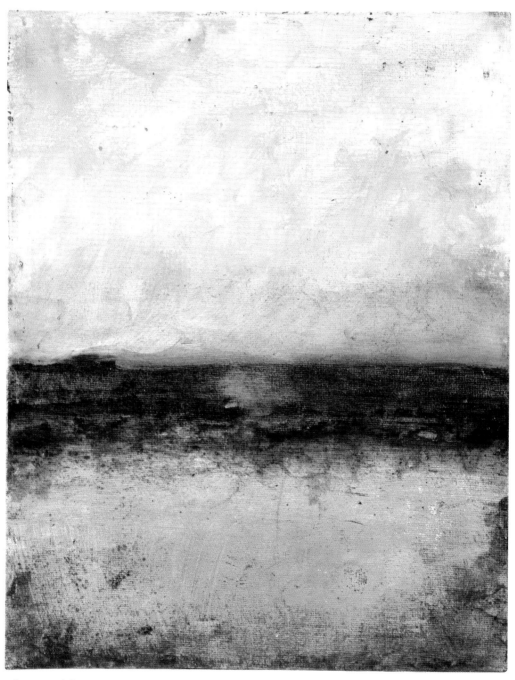

Distant Freighter – Re-inker glaze and acrylic on wood panel

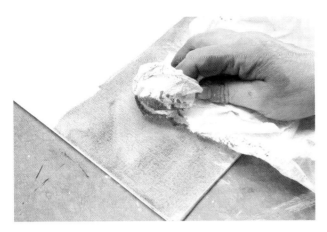

1 Use a pre-gessoed board. Brush a layer of Caramel re-inker on the bottom of the painting. Use the paper towel to blot and rub in the paint.

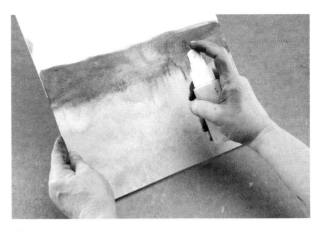

2 Above the Caramel area, brush a layer of Stream re-inker glaze. Spray a bit of rubbing alcohol to brush some of the Stream glaze onto the top of the Caramel layer.

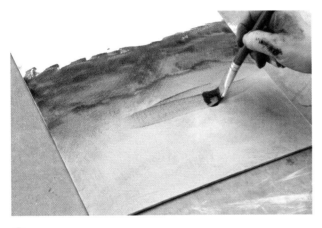

3 Brush layers of Butterscotch and Hazelnut re-inker glaze over the Caramel area, blotting as you go.

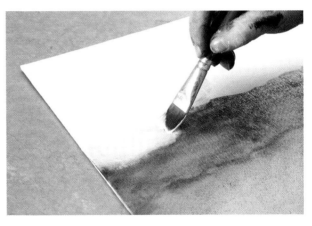

4 Cover the top half of the Stream area with Titan Buff acrylic paint and brush the Buff over the area above the blue.

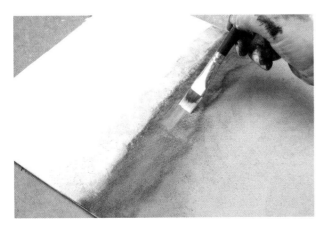

5 Brush over the Stream color with Denim re-inker and glaze. Add a little white acrylic paint to the Denim-glazed area in the center of the blue area.

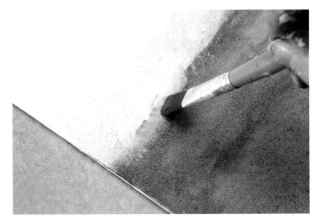

6 Add a little Raspberry re-inker glaze above the blue area on both the left and right sides.

7 To unify the piece, brush and blot small amounts of Hazelnut and Caramel re-inker glazes over the Buff area. Rub in some Rust re-inker glaze on the bottom of the piece and rub in just a touch on the top.

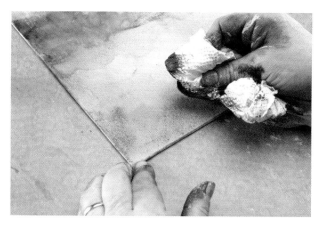

8 Add a bit of dark paint or re-inker glaze to the bottom left area.

THE FIRST SOFT SNOW!
ENOUGH TO BEND THE LEAVES
OF THE JONQUIL LOW.
~Bashō

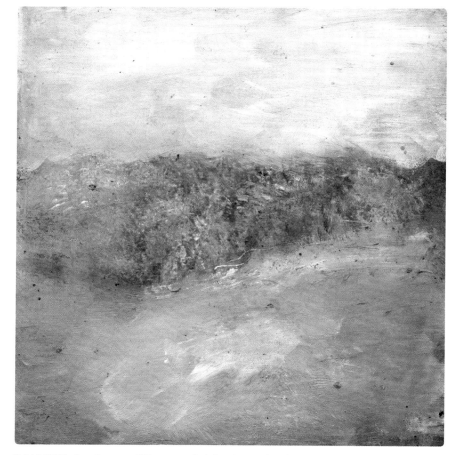

GALLERY: Landscape of Dreams – Re-inker glaze and acrylic paint on wood panel

Layers of re-inkers blotted with a sea sponge give the mountain shapes dimensional interest. The sweet spot of blue between the mountains and the snow makes the piece come alive.

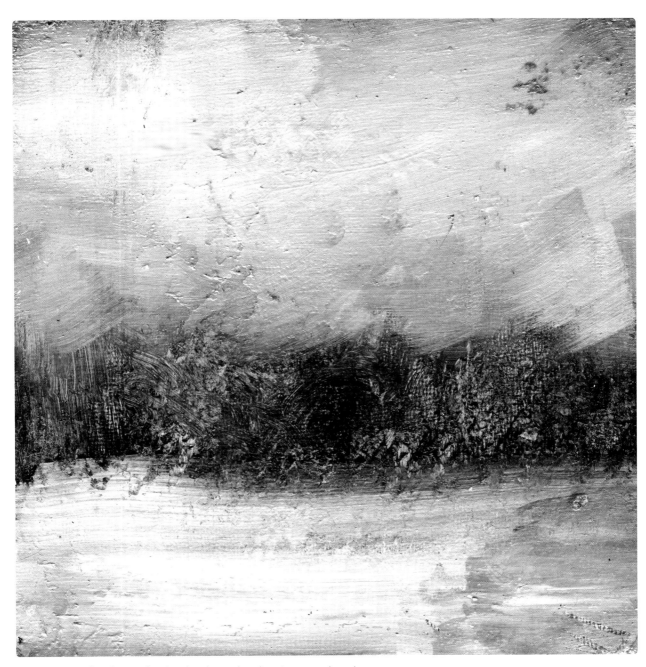

GALLERY: Robert's Woods – Re-inker glaze and acrylic paint on wood panel

A Cranberry re-inker glaze casts an evening glow. I sponged re-inker glaze through the center to create the mysterious woods.

2 patina of time: creating the effects of seasoning

My inspiration for the projects in this chapter comes from the effect of time and weather on natural and created objects and structures. If you're a mixed-media creator you probably love seasoned and layered surfaces and shapes that speak of time passing and the inevitability of change.

GALLERY: **Movement of Time** – Re-inker glaze, aluminum foil and acrylic on wood panel

Inspiration for the work in this chapter comes from rusted and tarnished metal, time-distressed wood, pit-fired pottery, peeling layers of paint and paper adorning old buildings and driftwood by the sea.

I think it's wonderful that many organic and fabricated objects become more beautiful as they age. The seasoning of time adds extra meaning and depth to things and to people, as well. There's randomness to the effects of patina that you can reproduce in the process of creating the pieces in this chapter. Your experimentation will result in surprising and pleasing outcomes! As you create, enjoy the process of change that your work will undergo.

In this chapter, I'll show you several ways to use acrylic paint and re-inkers along with an unusual ingredient—aluminum foil—to create the look of aged metal. You'll do some incising into your pieces to suggest the ravages of time on a painted surface. You'll use what you've learned about wabi-sabi texture and color to create work that is meaningful and expressive.

You may notice that in many of my completed projects and my gallery pictures, I have added more aging and patina than are shown in the step-by-step directions. Sometimes this comes about by happy accident when my hands have paint on them that gets on the piece in a pleasing way. Here are more deliberate methods for adding patina and seasoning to your pieces:

- Rub Slate or Mushroom re-inker in various areas around the piece.
- Sponge on acrylic paint in a neutral or brown color and wipe off, as desired.
- Collage a few specks of dry tea onto the surface of your piece.
- Rub your fingers or a towel onto an ink pad and rub a bit of ink onto the piece.
- Rub some instant coffee flakes into the piece.

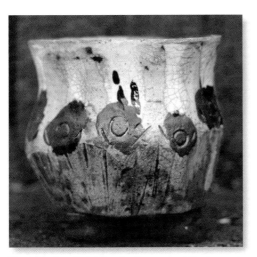

Traveler Bowl – by Dorothy Hearn, wood-fired ceramic

Using Your Inspiration Photo

This bowl is one of my prized possessions. It's pit fired, which means the clay bowl was fired in a pit dug in the earth or sand. Such firing produces cracks, discolorations and patina in a random process of transformation.

I love the surface of the bowl and also love the hand-built quirky quality of its design. It seems to have a jaunty and friendly personality.

I'm inspired by the appearance of the surface of this bowl and by its gorgeous imperfections. This surface has inspired several of my pieces.

WHAT YOU'LL NEED for this chapter

Acrylic gesso

Acrylic paint

Alcohol inks

Aluminum foil

Carving tool

Gel medium

Glaze medium

Paintbrushes

PanPastels

Paper towels

Pencil

Re-inkers

Rubber stamp and pad

Rubbing alcohol

Sponge

Wood or canvas panels or canvases

Spattering, Sponging, Dropping and Wiping

I've been talking a lot about blotting, wiping and so forth. It's time to take a look at ways these techniques and other alterations to your paint and ink layers can suggest patina and age.

You're going to blot, sponge, spatter, drop and wipe when you create your version of the following piece. In addition to alcohol ink and rubber stamps, you're going to use some household products such as rubbing alcohol and aluminum foil.

You can paint your foil pieces before or after you apply them to the support. Adding gel medium to your acrylic paint makes the paint stronger and more effective in covering the foil. If you want just a hint of color on the foil, add a bit of paint with acrylic glaze medium.

LOTUS LEAVES IN THE POND

RIDE ON THE WATER.

RAIN IN JUNE.

~Shiki Masaoka

White Bloom – Aluminum foil, acrylic, alcohol ink and stamp pad on board

1 On a pre-gessoed board, apply layers of Nickel Azo Gold, Titan Buff and Payne's Gray acrylic paint. Wait for each layer to dry before adding the next, wiping back as each layer is applied.

2 Squeeze Slate alcohol ink horizontally and then in vertical circles.

3 Squeeze Watermelon alcohol ink over part of the Slate areas. Blend these areas gently with a paintbrush.

4 Rub in a couple of small areas of blue paint below the horizontal Watermelon ink line. Soften these areas with a light application of the Nickel Azo Gold.

5 Tear off a piece of aluminum foil. I sometimes use foil for a palette, so if I have a paint-stained piece of foil, I use that. Use gel medium to glue down the foil where you want it on your piece.

6 When the foil is glued down, coat it with gel medium mixed with Nickel Azo Gold. Add a small area of Titan Buff paint as a highlight on the foil flower.

7 Make a stem using Payne's Gray and Ultramarine Blue. Sponge the Titan Buff and Nickel Azo Gold mixture over the stem when it's dry.

8 Dab a little rubbing alcohol in a few places.

9 Put Watermelon alcohol ink on a small brush and spatter some ink over the surface.

10 Rub the edges and a few areas of the piece with a dark brown ink pad.

11 Apply a square rubber stamp to one area. Smudge the stamped area and brush over it with glaze medium.

12 Gently sponge a bit of the Nickel Azo Gold over the stamped area.

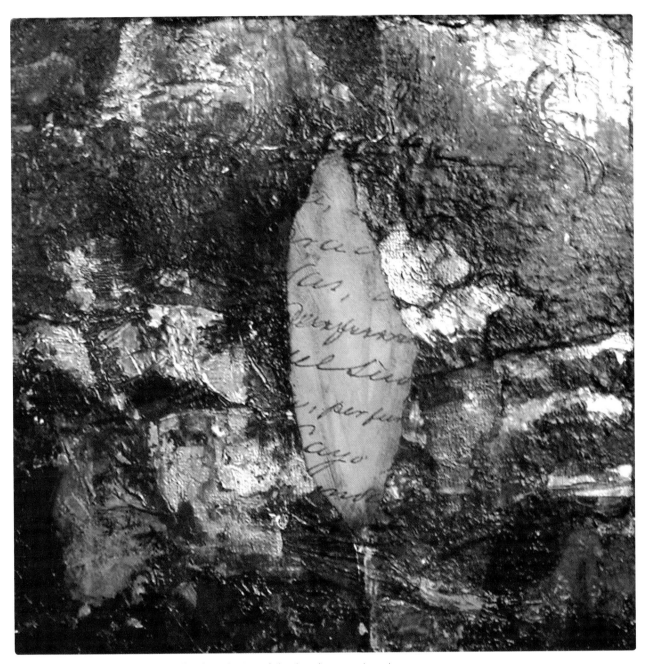

GALLERY: You Shine – Paper, re-inker glaze, aluminum foil and acrylic on wood panel

To make this piece, I first glued down a layer of tissue paper. I painted layers of re-inker glazes in Slate, Rust and black. I rubbed and wiped each layer. I added pieces of aluminum foil and glued them down with gel medium. I glued a vintage book fragment in the center to suggest a flower bloom. I added vertical lines to the book fragment with a small brush dipped in dark paint. I added re-inker glaze colors (Butterscotch, Caramel and Red Pepper) over the foil.

Scraping and Incising

I love the term for etching marks into a painted surface: *sgraffito*. This is an Italian word for a technique that dates at least back to the Renaissance. You'll recognize this term as the parent of our modern word, *graffiti*. This technique mimics the process of wear and tear over time.

There's something both playful and powerful about using a carving tool, a dental tool, an awl or other sharp tool to scratch the surface of your piece. You can use this tool to create a representational design, to add text or to give your piece a "street" look.

In this project, you're going to use sgraffito to make a framed image in the center of the piece. For this project I suggest that you make your lines and drawings simple and even primitive, in keeping with the wabi-sabi style. You'll be using re-inker glaze and acrylic paint to add to the seasoned look. You'll add touches of PanPastels, small containers of pure pigment that are pressed like face powder in a compact.

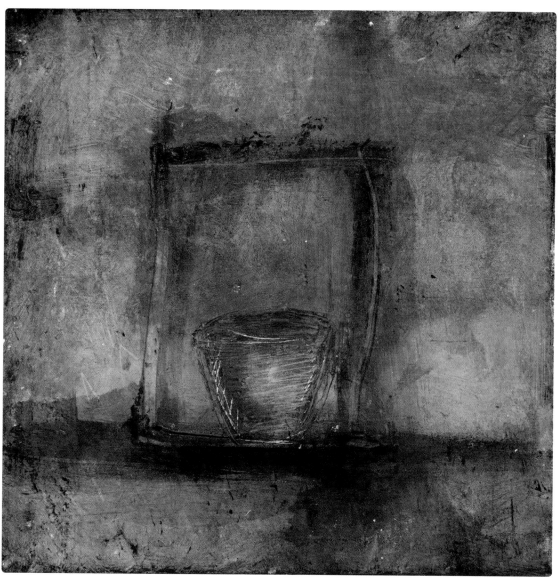

Waiting to Be Filled – Acrylic paint, re-inker glaze, PanPastel, graphite and ink on wood panel

 visit www.createmixedmedia.com/wabi-sabi for extras

1 Layer Micaceous Iron Oxide acrylic paint onto a pre-gessoed surface.

2 When the layer of Micaceous Iron Oxide acrylic paint is dry, add a layer of Nickel Azo Yellow acrylic paint.

3 Add one more layer of the Micaceous Iron Oxide and of the Nickel Azo Yellow.

4 Add touches of Viridian acrylic paint and wipe.

5 Brush down a layer of Ginger re-inker mixed with glaze medium.

6 Squirt black acrylic paint onto the support in a square shape. Flatten the paint down and take up any extra with a paper towel.

7 Incise into the black lines with a carving tool.

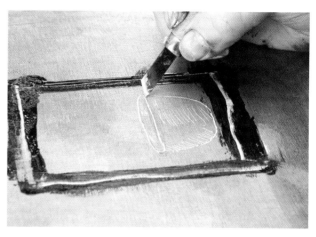

8 With a pencil, draw a design, such as a cup. Incise around the drawing, adding incisions for shading.

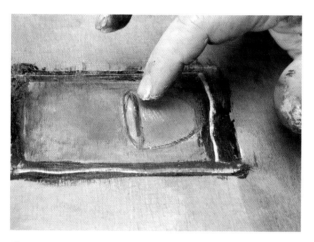

9 Add a layer of Payne's Gray and gold to the background of the incised square, and rub a little Burnt Sienna PanPastel into the drawn area. Incise again—or scrape incised areas—for definition.

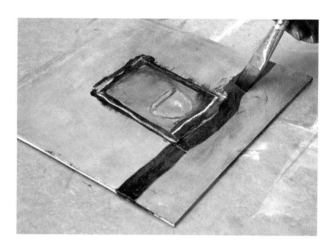

10 Paint another area of Ginger re-inker mixed with glaze below the incised area. Wipe the area and finish by blackening the edges and corners of the panel with a stamp pad.

wabi-sabi wisdom

- You can fill in the incisions you make with PanPastels (as I did here), re-inkers, permanent dark ink or acrylic inks.

- The more layers of color you have put on your piece, the more color will show in the incisions.

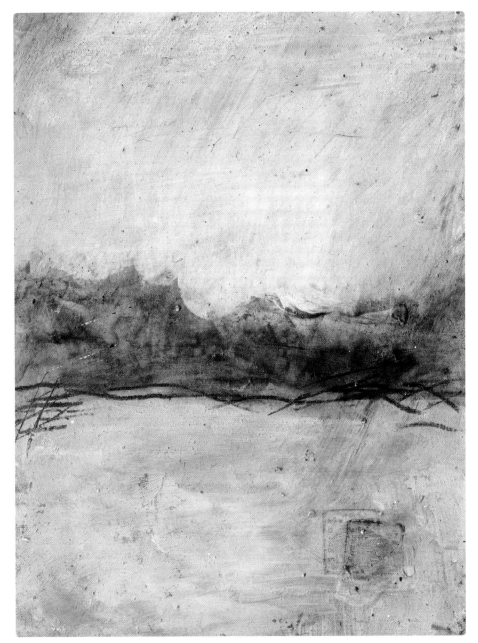

GALLERY: Salmon Sky – Acrylic and re-inker glaze on wood panel

This piece reminds me of sunset and mist. I rubbed the re-inker glaze into the support for a soft effect. I used my brush handle to incise lines in the center of the piece, and I added rubber stamping in the lower right corner as a finishing touch.

CHERRIES BLOSSOM

AND THEN FALL DOWN—

ALL THIS IS THE WAY OF THINGS …

~Enomoto Seifu-Jo

3 strata of time:
creating layers of texture

When I layer on the texture with various techniques and materials, I feel like I'm doing my best to imitate what nature does. Layers of peeling plaster on buildings, layers of weather damage, layers of geological strata and the lines of experience on an older person's face are all visible testaments to the passing of time. Time passes and stories evolve, waiting to be discovered or imagined.

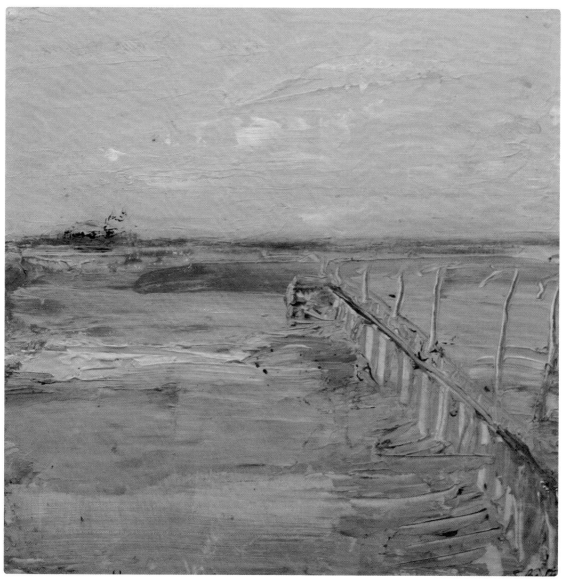

GALLERY: Pier – Acrylic on wood panel

Former owners of our house, built in 1905, added an extra layer of drywall to the wall that separates the entry hall from the living room so that the doorway between the rooms was no longer visible on the living room side. We removed the extra drywall to restore the opening. When we removed the drywall, we found the original wallpaper around the doorway. We kept meaning to cover it over but finally decided we like the way it looks as is. Being able to see a bit of the original wallpaper is like seeing the history of the house and those who have lived in it.

Layers of texture suggest history in a similar way. To me, layers of texture also suggest the complexity of the world and the objects and beings in the world. With texture, even your simplest pieces can be full of meaning and beauty. Feel free to use my texture photos from earlier in the book for your inspiration, or better yet, go out and take your own.

In this chapter, you'll explore many materials and methods to evoke wonder at life's tenacity, complexity and mystery. A variety of papers, plaster, deliciously gooey acrylic mediums and painting knives will allow you to create with abandon!

WHAT YOU'LL NEED for this chapter

Acrylic paint	Neocolor II crayon
Art tissue paper	Oil paint
Carving tool	Paintbrushes
Cold wax medium	PanPastels
Construction paper	Paper towels
Craft knife	Pre-gessoed panels or canvas boards
Garment pattern	Re-inkers
Gel medium	Rubbing alcohol in a spray bottle
Glaze medium	Sponge
Gold transfer foil	Textured packing material or other texture tool
Joint compound	Trowel
Medium-sized painting knife with a diamond-shaped tip	Vintage book page

Using a Painting Knife

I love working with a painting knife in place of a brush. Pushing paint around with a knife is wonderfully freeing. You'll find you can use your knife to layer on paint, to smooth out paint, to create peaks in paint, to incise or scrape off paint and to mix colors on your support. Using a painting knife forces you to simplify your compositions and to emphasize color, texture and form instead of detail. You may want to experiment with painting knives of different sizes. In this project you'll create a simple design that will be made complex and interesting through thick applications of paint and through deep incising.

THE CROW HAS FLOWN AWAY:
SWAYING IN THE EVENING SUN,
A LEAFLESS TREE.
~Soseki Natsume

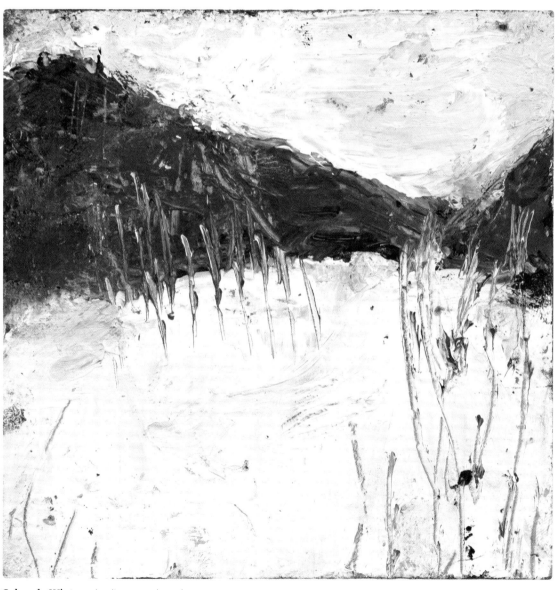

Colorado Winter – Acrylic on wood panel

1 Paint a layer of Payne's Gray acrylic paint on a pre-gessoed panel. When the gray layer is dry, layer on white acrylic paint with a painting knife.

2 Add red acrylic paint with the painting knife to form mountains.

3 Layer Payne's Gray paint over the red mountain area with a painting knife. Leave a little of the red showing.

4 Using the painting knife, incise vertical lines on the left and right sides of the painting.

5 Rub in a little ochre paint in various areas of the piece.

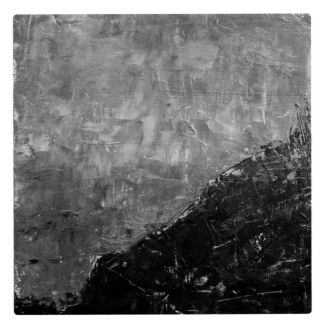

GALLERY: Aftermath – Acrylic on wood panel

Layers of different colors applied with a painting knife add a rich and glowing effect to this simple composition.

Plaster It On

Remember those pictures from my photo gallery of mysterious old walls with layers of history in the form of plaster? You're going to use joint compound, a form of plaster, to create your own fresco-like walls of memory. You'll find that playing with plaster gives you that childlike feeling of playing in wet sand at the beach. In this project we'll use oil paint, re-inker and transfer foil to add to the richness of the plaster layers. You can use acrylic paint as well as oil paint to color your plaster pieces. Plaster loves both acrylic and oil.

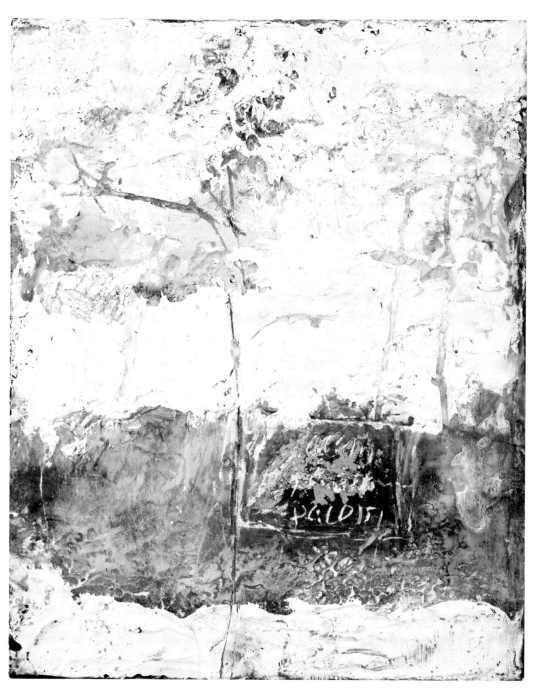

Pacem – Plaster, oil paint, oil pastel, re-inker, gold transfer foil and cold wax on wood panel

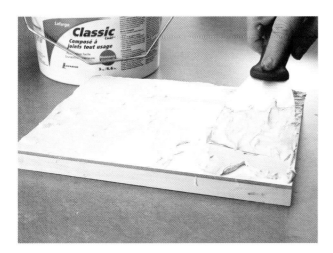

1 Apply joint compound to a wood panel with a trowel.

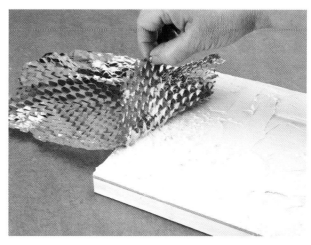

2 After the compound has set for about ten minutes, use textured packing material to texture the plaster in a few areas.

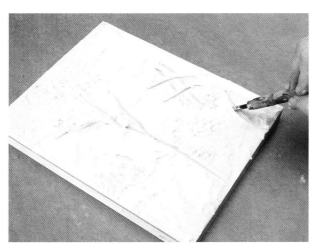

3 Use a pottery carving tool to incise lines.

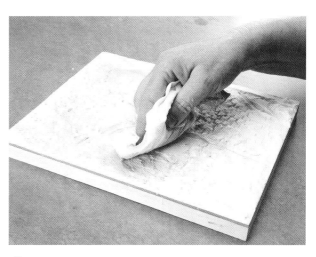

4 When the plaster is dry, rub in Naples Yellow oil paint mixed with cold wax medium.

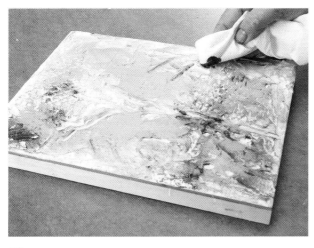

5 Rub in Azo Green oil paint mixed with cold wax in a few areas.

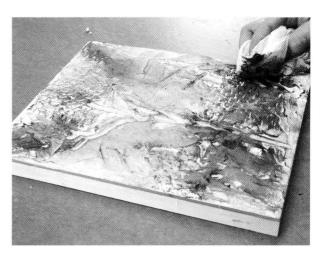

6 Repeat the process with Burnt Umber oil paint and cold wax.

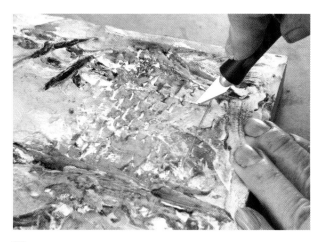

7 Incise an oblong shape about two-thirds of the way down the piece. A craft knife works well for this.

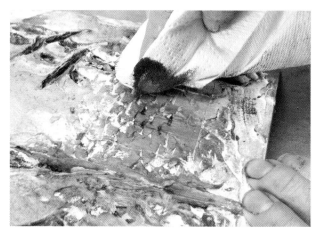

8 Apply Crimson re-inker in the shape.

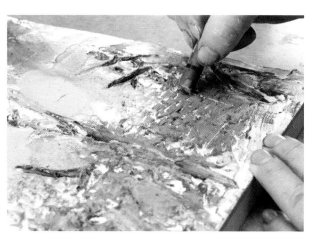

9 Outline the Crimson square with an iridescent gold oil pastel.

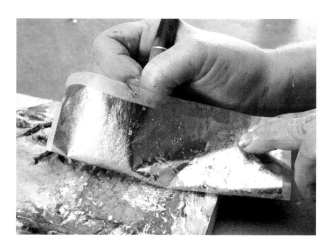

10 Apply gold transfer foil onto the shape.

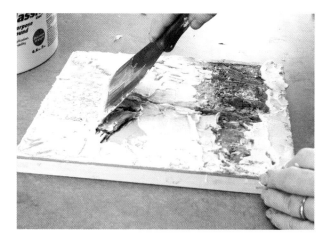

11 Apply another layer of joint compound along the bottom edge of the piece and unevenly over other areas, leaving the shape and a wide band of the original layer showing.

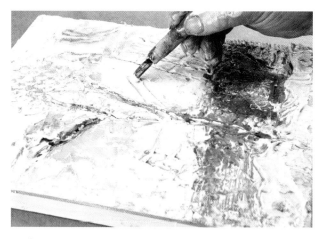

12 Incise in a few areas and re-incise where needed.

STILLNESS. OUT OF THE RAIN

A BUTTERFLY

ROAMS INTO MY BEDROOM.

~Enomoto Seifu-Jo

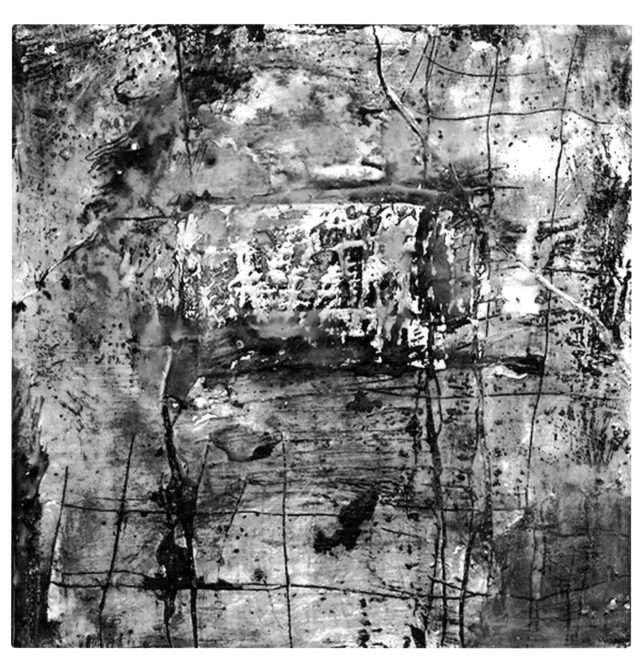

GALLERY: Wax Meets Plaster – Plaster, acrylic, gold transfer foil and beeswax on wood panel

Tissue Paper

This humble, fragile paper has so many uses besides adding heft to shopping bags. Tissue paper comes in rich colors now, not just the pastel hues I remember from my childhood. If you save wrapping and tissue paper, this is an ideal project for you. Tissue paper naturally wrinkles when collaged to a support. The wrinkling adds vital interest to your piece. To enhance this texture, you can crumple the tissue even more before you collage it down. In this project, we'll create an imaginary still life with tissue paper, construction paper, rubber stamps and a little acrylic paint. The wrinkles and touches of dark paint add to the wabi-sabi feel of the piece.

SPRING RAIN—
ALL THINGS ON THE EARTH
BECOME BEAUTIFUL.
~Chiyo-ni

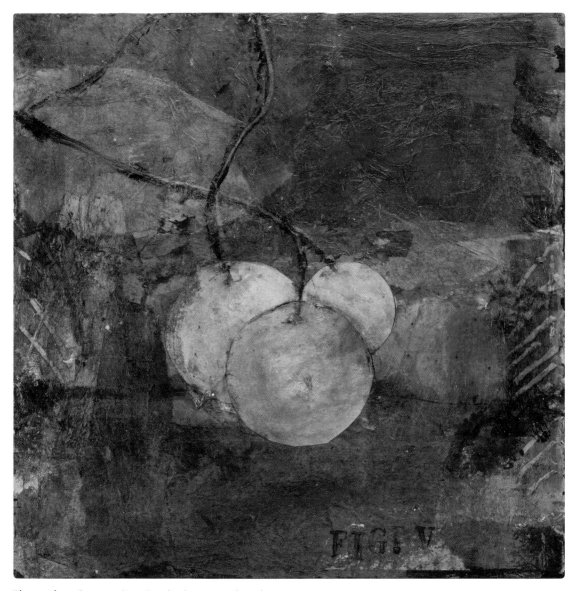

Figure Five – Paper, acrylic and acrylic glaze on wood panel

In addition to the steps on the right, I added a final touch using rubber stamps. The *Fig. 5* at the bottom of the piece is a reference to scientific and botanical drawings.

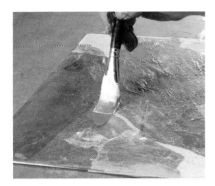

1 Collage torn lightweight paper and blue tissue paper randomly to a pre-gessoed panel or canvas.

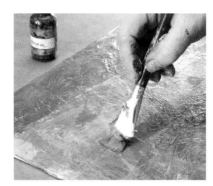

2 Collage torn light lavender tissue paper and magenta tissue paper down in a random pattern, overlapping layers as desired.

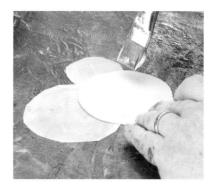

3 Cut circles of construction paper or card-stock—one smaller than the others —and collage the circles down so the smaller circle and one of the larger circles are partially hidden by one of the larger circles.

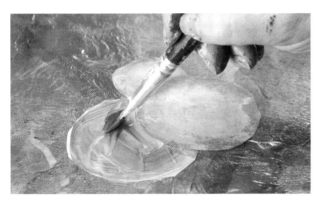

4 Color the circles lightly with Rust re-inker and yellow acrylic paint mixed with lots of glaze medium. Rub off the Rust, yellow and glaze mixture on one side to indicate a light area. Rub off the mixture in a small area, which will represent a highlight.

5 Make stems and branches for the fruit using a narrow brush dipped in Payne's Gray acrylic paint. Incise into the paint to represent light areas. Using a small brush, add a narrow Payne's Gray line between the fruits.

6 Add blue paint to areas on either side of the panel, and incise into the wet paint with a brush handle. Seal when dry with a layer of glaze medium to make sure all the paper stays down.

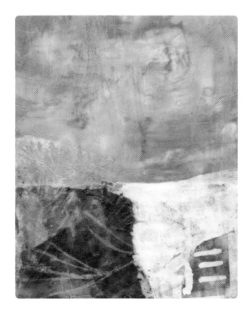

GALLERY: Chosen – Encaustic and stamped tissue paper on wood panel

I used translucent layers of encaustic paint with tissue paper printed with a hand-carved stamp in this simple but rich piece.

Specialty Papers

I go wild when I visit my local paper store. It's so hard to choose just a few of the hundreds of papers available. I tend to go for papers with rich, muted color and interesting texture for wabi-sabi pieces. If I see a more elaborate design I want to use, I'll use only a small amount of it in one of my pieces. I get just as excited by the vintage papers available at flea markets and secondhand stores. In this chapter, I show you how to use some of my favorite papers for wabi-sabi work. These include lace paper and dress pattern paper. (We'll use another of my favorites, Mexican Amate Marble Lace paper, in a later chapter.) A touch of PanPastel adds interest and depth to this project.

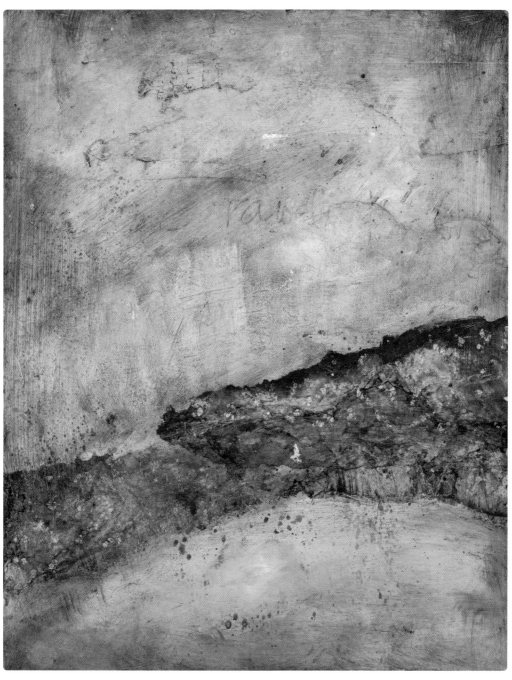

Shelter – Lace paper, Neocolor II crayon, re-inker, acrylic paint and PanPastels on wood panel

 visit www.createmixedmedia.com/wabi-sabi for extras

1 Coat a gessoed or ungessoed wood panel with Buff paint. Add three pieces of a lacy specialty paper in a way that suggests a rock formation.

2 Add bright red paint over the Buff paint and lacy paper and wipe. Add a little blue-green paint to the upper part of the piece. Add Buff over the paint to soften it, if necessary.

3 Use a Neocolor II crayon to add handwritten text in the area where the Buff and blue paints meet.

4 Sponge lightly over the text with Buff paint.

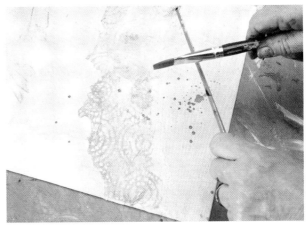

5 Mix bright red paint with a little water and spatter over the lower portion of your piece.

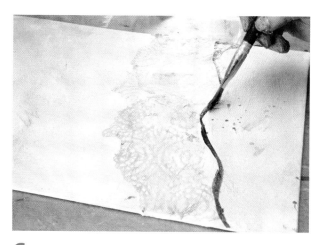

6 Brush Denim re-inker near the bottom of the rock formation.

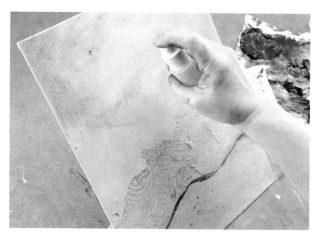

7 Spray rubbing alcohol on the top third of the painting and blot it.

8 Rub gray and sienna PanPastels into various areas of the piece. Finish the piece by adding additional layers of paint and PanPastels. Rub in and scrape back until you are satisfied with the results.

wabi-sabi wisdom

Go ahead and keep it simple when you want to create lots of layers and when you want to use several techniques in one piece. The color and texture you'll create will make even a simple design rich and interesting.

A GIANT FIREFLY:

THAT WAY, THIS WAY, THAT WAY, THIS—

AND IT PASSES BY.

~Issa

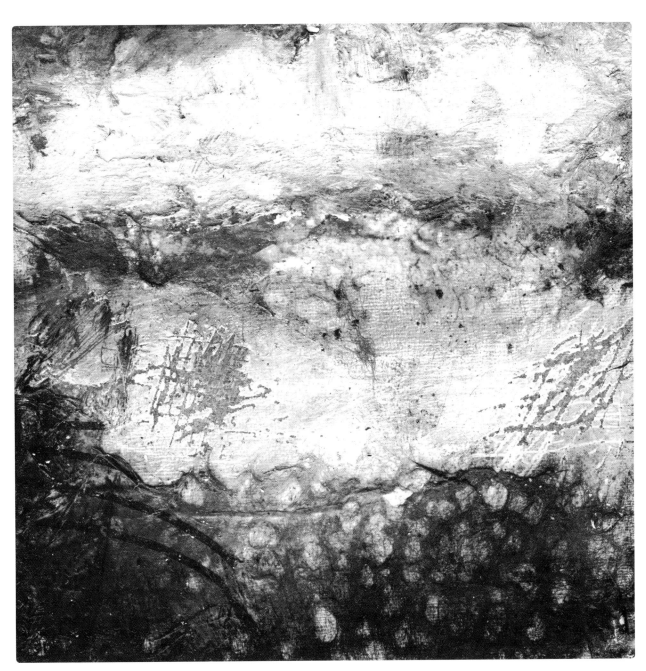

GALLERY: Faerie – Acrylic, re-inker, dress pattern and lace paper on wood panel

I put lots of layers on this piece and incised deeply in the center area.

Vintage Paper and Dress Pattern

You're going to incorporate two of my favorite paper media into this re-inker glaze piece. For this project, I used a fragment of an old pharmacopeia as well as dress-pattern paper. I love the pliability of patterns and I love the lines, text and arrows on the pattern. And vintage book and newspaper pages—where do I start? I love the color of the aged paper, the look of vintage typesetting, the chance to feature a foreign language and the chance to choose words that add meaning to my pieces.

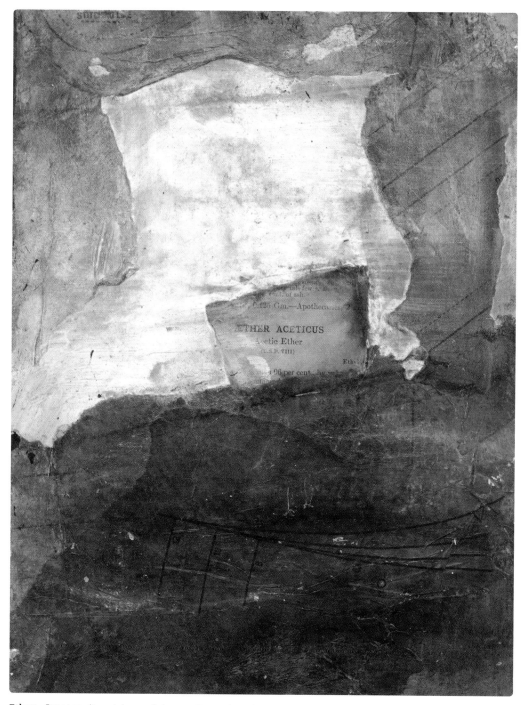

Ether – Paper, acrylic, re-inkers and glaze medium on board

1 On a pre-gessoed board, apply a layer of Butterscotch re-inker and glaze medium. With your brush, scrub some Buff into the Butterscotch layer.

2 Collage pieces of pattern paper onto the board.

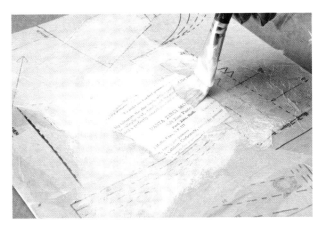

3 Tear off some of the pattern paper and rub white acrylic paint into the area where the paper was removed. Add a piece of a vintage book page just off center in the white area.

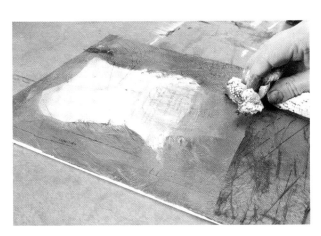

4 Add a layer of Rust re-inker glaze to all but the white area.

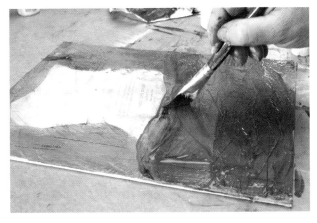

5 When the Rust layer is dry, add a layer of Ginger re-inker glaze.

6 Add Butterscotch re-inker over the text area.

7 Add Payne's Gray acrylic paint to suggest a shadow over the text area.

8 Add touches of Butterscotch over the top area and blend a little into the white area. Blot these areas.

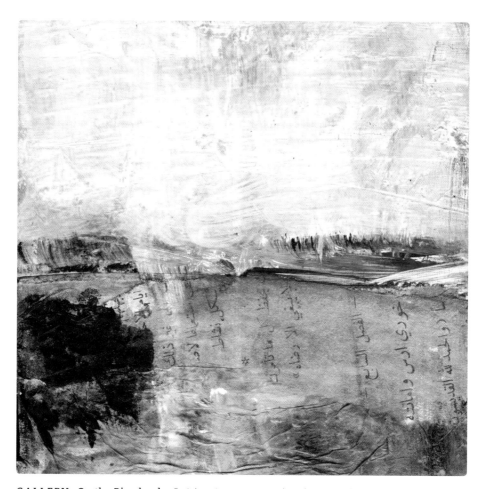

GALLERY: **On the Riverbank** Re-inker, vintage paper and acrylic on wood panel

I used wrinkled tissue paper at the bottom of the piece and vintage Asian paper in the middle area. The paint went on after that, creating a sense of mystery in this abstract scene.

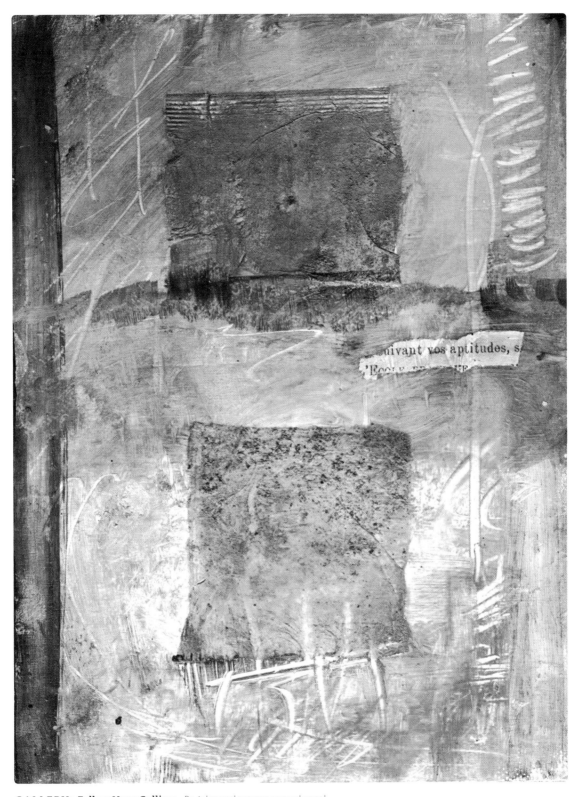

GALLERY: Follow Your Calling – Re-inker and paper on wood panel

Here the paper elements include dried used tea bags and a snippet of vintage text.

Gluing On and Tearing Off

When people ask what media I work in, I often tell them that I don't do any kind of art that can't be reworked. After I got that *C* in eighth-grade art for failing to draw an accurate floor plan, I've pretty well accepted that exact, perfect work is not my forte. I love to layer, paint over, scrape back and tear off. I'll do these things when I want to make changes to what I've done, but sometimes I'll do them on purpose from the beginning of a piece. In the following project you'll tear some stuff off and put some stuff on. You'll transform your less-favored work into something new.

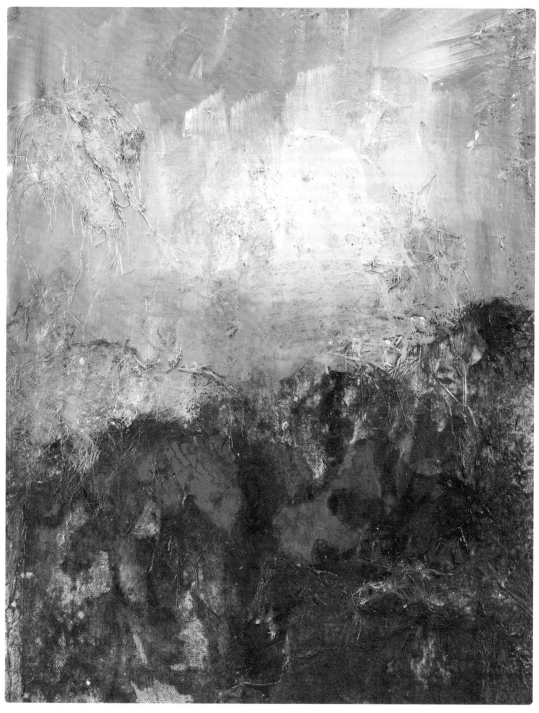

Canyon Sunrise – Paper, acrylic and re-inker on board

 visit www.createmixedmedia.com/wabi-sabi for extras

1 To prepare the supports, take an old collage you don't care for, and tear and scrape off all the paper you can. (Wetting the paper helps.) Glue down any remaining paper with gel medium. Collage lacy paper over various areas with gel medium.

2 Add Pesto re-inker glaze to the bottom half of the surface and allow the ink to dry completely.

3 Add additional re-inker glazes in various colors to the surface, letting each dry before adding the next one.

4 Mix Buff and Ultramarine Blue acrylic paint over the top half of the painting, leaving the bottom of this area uneven. Let some of the re-inker colors show through.

5 Lighten the center of the blue area with Buff, letting the brushstrokes show.

HARVEST MOON:

AROUND THE POND I WANDER

AND THE NIGHT IS GONE.

~Bashō

GALLERY: Autumn at Lost Lake – Re-inker, paper and acrylic on wood panel

I tore off paper I'd collaged onto the center of the piece. This created a mottled area where some of the original paper remained. I went over the area with glaze medium to seal it and then I added a bit of color.

throw in the towel:
working with the unexpected

Give your inventiveness full rein as you experiment with the techniques and ideas in this chapter. Your guiding mantra might be *what if...* when it comes to adding unusual materials to your piece. My only caveat is to look for organic materials, rather than, say, plastic.

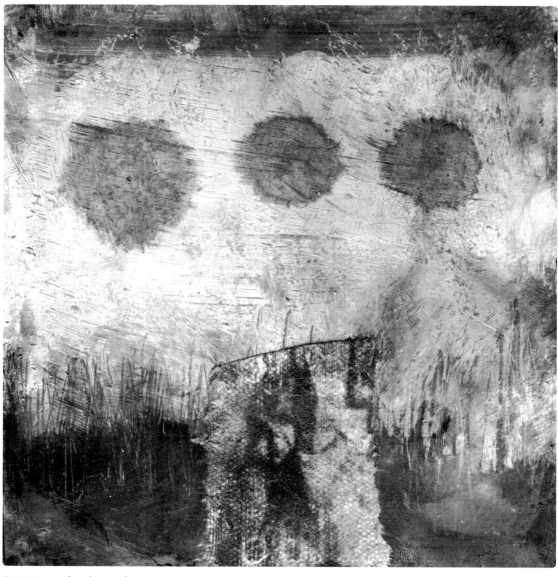

GALLERY: **The Time Before** – Mixed media on wood

Search your work area for stained paper towels or paper rags, scraps of vibrant paper and that old tea bag sitting in your cup from yesterday. Wabi-sabi suggests the transformation of ordinary things and that's just what we are going to do in this chapter.

You'll explore the "old paper" look you can achieve with used tea bags. Like me, once you discover this simple and elegant technique, you'll start drinking a lot more tea! You'll also start saving some of your stained paper or shop towels for use in textural collages. I'll introduce you to some of my favorite specialty papers, including one paper that mimics the look of straw but is actually made from bark. You'll learn how to use cheesecloth to create mysterious and gorgeous effects.

I'll show you how you can give new life to old book pages and dress patterns and how to mute color and infuse interest using them. You'll see how you can add silk yarn, instant coffee and vintage stamps for minimalist work with maximum punch.

The chapter title also refers to knowing when it is time to change direction. I'll show you how to find new purpose in old, forgotten pieces. Our inspiration for this process will be Kali, the Hindu goddess of destruction and creation. Another inspiration could be the Phoenix, the mythical bird that burns then rises from its own ashes. As artists we are called on to add, subtract and add again, until we reach the point of falling in love with our creation.

WHAT YOU'LL NEED for this chapter

Acrylic gel medium

Acrylic paint

Alcohol ink

Black gesso

Cheesecloth

Faux metal flakes

Glaze medium

Incising tool

Instant coffee

Mexican Amate Bark Marble Lace paper

Neocolor II crayon

Old painting

Paintbrushes

Paper shop towels or rags

Permanent fine-point marker

Pre-gessoed wood panel, canvas or canvas boards

Re-inkers

Silk sari yarn

Used tea bags, dried

Vintage book pages and newspaper

Vintage postage stamp

Water

Using Tea Bags

Old, dried tea bags can add magic to your artwork. It's no joke. Each tea bag has a different pattern of staining. Some tea stains are subtle, while others are more obvious. Tea bags containing berry teas are particular favorites of mine due to their rich crimson stains. I use tea bags to create an aged look, to mute a too-bright color and to add texture. I like to tear off the telltale edges of the tea bags before I use them. Once they're on a piece, they won't look like tea bags at all, but rather like a mysterious vintage surface. In this project you'll get to play with this inventive technique.

NEW YEAR'S DAY—
THE SOUND OF WATER
FROM A CREEK.
~Raizan

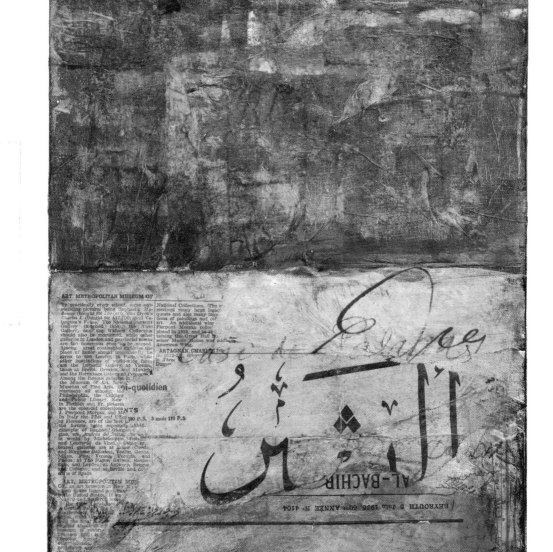

Casa de las Palabras – Mixed media on board

1 Using a pre-gessoed panel, canvas or canvas board, paint a layer of Green Turquoise acrylic paint over the top of the piece.

2 Paint a layer of Buff acrylic paint over the bottom of the piece.

3 Collage a variety of text: pieces from vintage books, newspapers and dictionary pages. Use pages that have small illustrations on them.

4 Paint a layer of Nickel Azo Gold paint and glaze medium over the entire piece and blot it. When the gold layer is dry, add a layer of transparent Red Iron Oxide paint and glaze medium. Wipe the area lightly with a paper towel.

5 Mix some Red Iron Oxide with gel medium and paint an uneven horizontal line above the text area.

6 Take a dry used tea bag and cut off the top under the staple. If you have a lot of patience you can remove the staple with needle-nosed pliers instead. Open up the tea bag at the seam and empty the tea into a container. Repeat with other tea bags as needed. Collage the tea bags and torn pieces over the top area of the piece. Look for interesting tea stains to include.

7 With a small brush, dash down a small area of bright red acrylic paint on the line across the piece.

8 Brush on a short line of sky blue paint below the red area.

9 Hand-write text in the upper gold area with a watercolor crayon. Rub gently to partially obscure the text.

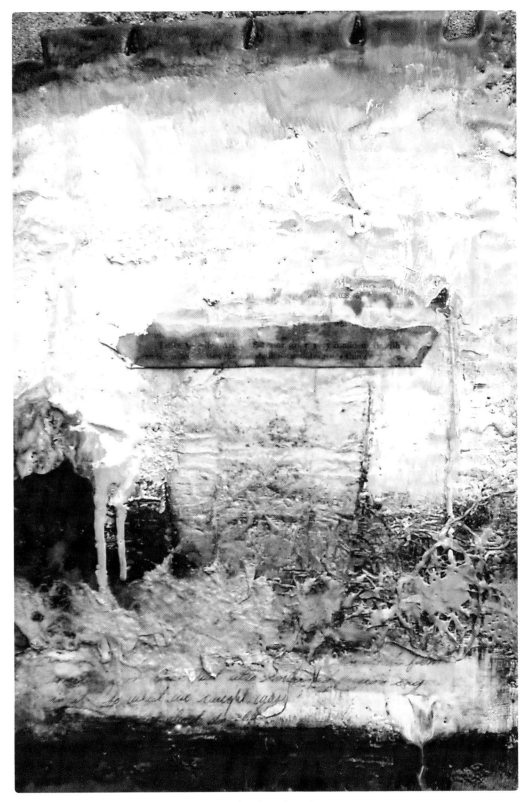

GALLERY: Teahouse – Encaustic and collage on found wood panel

I used part of an old shelf for this piece's support. You can find interesting wood like this at recycling and reuse stores, garage sales or even in a free pile outside a secondhand store. Used tea bags form the "house" in this stylized mixed-media piece.

Using Stained Shop Towels

I acted on impulse the first time I used this technique. The paint- and ink-stained paper shop towel lying next to me looked so pretty and interesting that I just thought, *What if...?* I added the shop towel courtesy of a thick application of gel medium, and it worked just fine. When I use a thicker towel, I like to add other thick elements as well. This piece is called *Kabuki*, named after a highly stylized form of drama and dance theater in Japan. The stained shop rag used here reminds me of a highly patterned kimono.

RIGHT AT MY FEET—
AND WHEN DID YOU GET HERE,
SNAIL?
~Issa

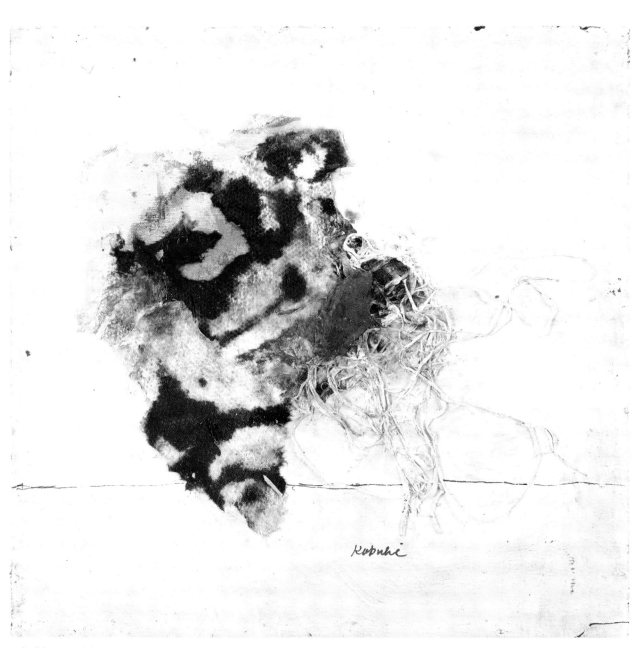

Kabuki – Stained shop rags, pen, Mexican Amate Bark Marble Lace paper and acrylic on wood panel

visit www.createmixedmedia.com/wabi-sabi for extras

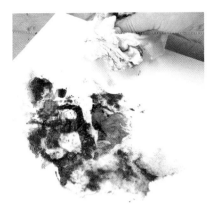

1 Paint a layer of white acrylic paint over a light-colored wood panel. Pat with a paper towel. Tear a stained shop towel and use gel medium to collage a piece near the center.

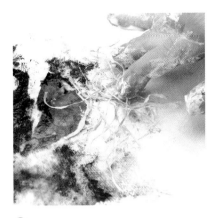

2 Tear off a piece of Mexican Amate Bark Marble Lace paper and loosen the threads. Secure the Amate paper with gel medium.

3 Go over the paper areas randomly with a wash of blue acrylic paint and glaze medium. Then brush on a mixture of pink and beige acrylic paint to make a partial square in the upper left of the collaged area.

4 With a fine-point marker, draw a horizontal line across the piece, about a quarter of the way from the bottom of the panel.

5 Write a small amount of text with the same marker in the middle of the area and under the horizontal pen line.

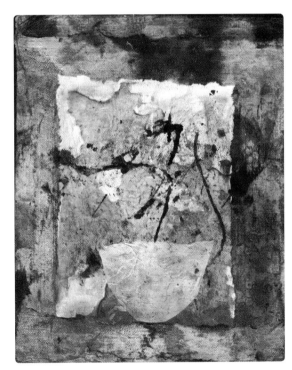

GALLERY: Contemplative Chaos – Mixed media on wood

In this piece, stained paper shop rags form a rich frame around the central images.

Amazing Cheesecloth

Cheesecloth isn't just for the kitchen. It does amazing things for wabi-sabi. You can stretch it, paint over it and completely disguise it. Gel medium will seal and secure the cloth while allowing the hole patterns to show through. Go ahead and use plenty of medium under and over the cheesecloth to hold it on the support. In this project you'll elevate humble cheesecloth to High Art.

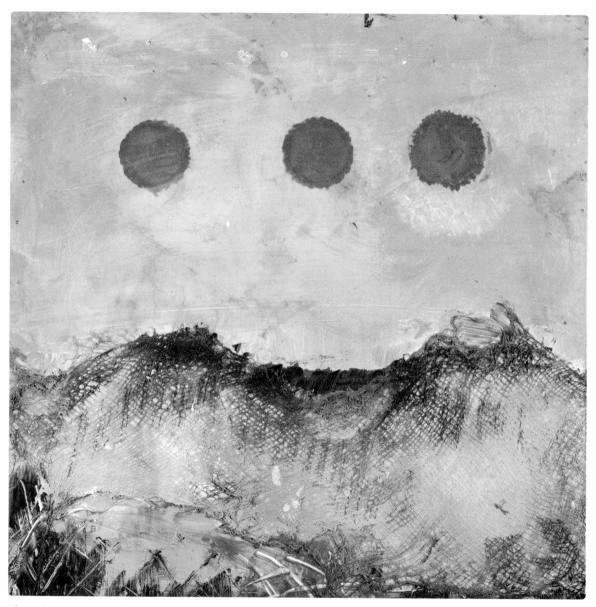

Three Suns – Acrylic, re-inker glaze, alcohol ink and cheesecloth on wood panel

1 Apply a base coat of Sunset Orange re-inker mixed with glaze medium onto a smooth pre-gessoed board or panel. Blot unevenly with a paper towel. Add Pastel Yellow and Medium Yellow paint, rubbing the colors into the board. Collage down a piece of cheesecloth, stretching the cloth across the panel and shaping it to resemble a mountain.

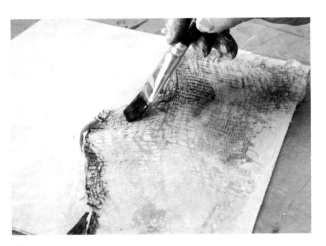

2 Paint Sunset Orange and Bottle Green re-inker glazes over the cheesecloth. Add a small amount of black re-inker glaze in various areas.

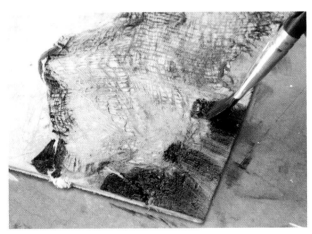

3 Paint the bottom area with Lettuce and black re-inker glazes.

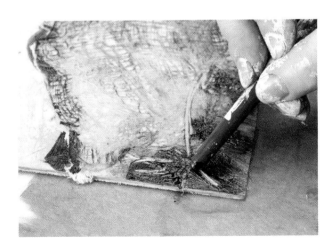

4 Incise designs into the bottom area, where the surface is not covered by the cheesecloth.

5 Add three circles in the upper area of the painting by squeezing Watermelon alcohol ink over the wet paint.

wabi-sabi wisdom

To add an aged look to cheesecloth, soak the cloth in cold strong coffee or tea.

6 Dip a piece of paper towel in glaze medium and use it to wipe off some of the color around one of the circles.

7 Paint a narrow line of the Sunset Orange re-inker glaze across the top of the cheesecloth area.

8 With a wide brush, add a thick wash of the orange re-inker glaze over the whole piece. Use a paper towel to pat up some of the glaze.

visit www.createmixedmedia.com/wabi-sabi for extras

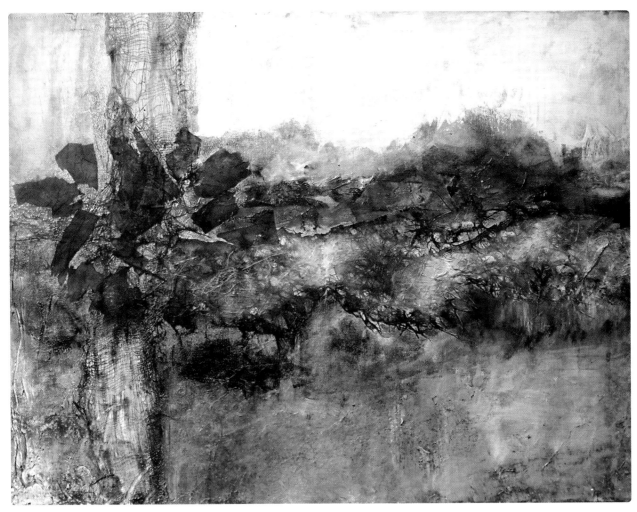

GALLERY: Tristen – *Tristen Collins and Serena Barton;* Acrylic, re-inker glaze, cheesecloth and tea bags on canvas

This piece is mostly the work of one of my women's art group members, Tristen Collins. She's responsible for the gorgeous re-inker color and the inventive use of cheesecloth and tea bags. At her request, I worked on the background, adding the Payne's Gray and Buff and other touches to make the yellows and oranges pop. We took turns working on the piece for quite a while. At one point we realized we had gotten too "picky" and had taken some of the life out of the work. I then went at the piece with a spray bottle of rubbing alcohol and a big brush until it came back to vibrant life. Working as a team was a lot of fun for us.

CROSSING THE

SUMMER RIVER,

SANDALS IN MY HAND.

~Buson

Coffee, Metal Flakes, Yarn and Stamps

In this project you'll use a little of this and a bit of that—elements you may well have around your house or art-making area. I love to drink quality brewed coffee when I wake up in the morning. However, I've learned to keep some inexpensive instant coffee around at all times. Instant coffee crystals mixed with a little water make a rich burnt umber color that looks great on a gessoed panel. Any crystals that don't dissolve all the way add texture. I love how thin metal flakes lend excitement to a simple piece. Vintage postage stamps are some of my favorites for adding those sweet spots that bring the piece together. Yarn supplies fascinating texture and color. In this project I use silk sari yarn. If you have other kinds of silky yarn available, feel free to use that.

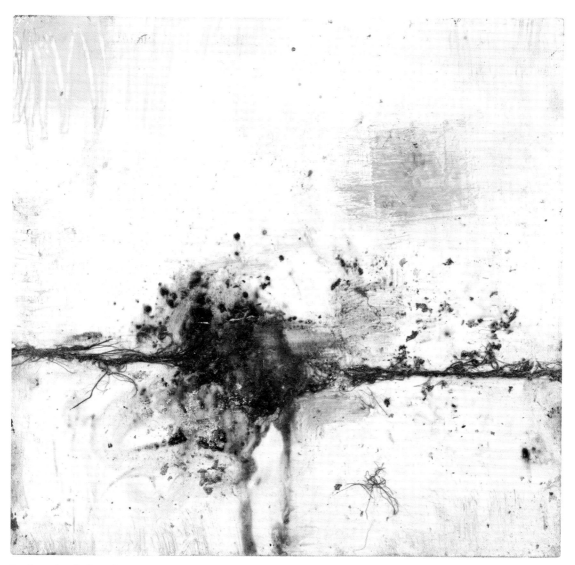

Beginner's Mind – Coffee, yarn, metal flakes and acrylic on wood panel

1 Start with a pre-gessoed panel or canvas board. Dip a damp paintbrush into instant coffee crystals. Brush a clump of coffee onto the panel.

2 Brush gel medium thickly onto the coffee area. Tilt the board up and toward you so a little of the coffee drips down to the bottom of the panel.

3 Use your brush to smear a bit of the coffee outward.

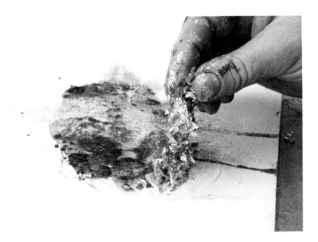

4 Sprinkle a small amount of metal flakes into the area of the piece covered with gel medium.

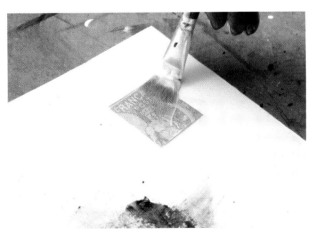

5 Collage a vintage postage stamp in the upper right corner of the panel. Brush white paint over the stamp and blot the excess, partially obscuring the stamp.

6 Collage two strands of multi-textured yarn, placing one strand on each side of the coffee area.

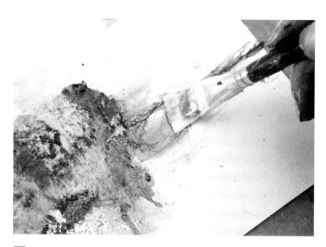

7 Brush a small amount of light red paint under the yarn line to the right of the coffee area.

8 Brush a little of the red paint near the bottom of the coffee area.

9 Use a Neocolor II crayon to lightly sketch in text in the upper part of the piece. Use a paper towel to rub in and take up most of the text, leaving only a hint of it.

AUTUMN MOONLIGHT—
A WORM DIGS SILENTLY
INTO THE CHESTNUT.
~*Bashō*

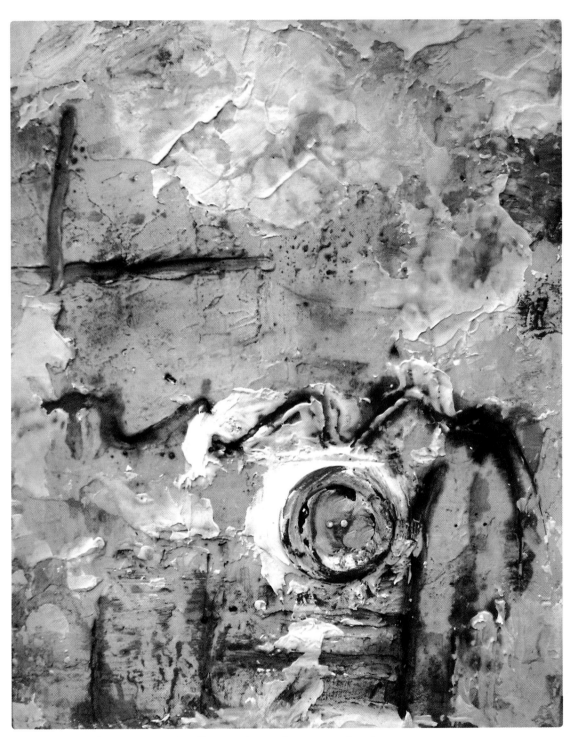

GALLERY: Portal – Plaster, PanPastels, coffee, tea and vintage button on wood panel

I added instant coffee and grains of tea to this plaster piece to give it a natural, aged effect.

The Cover-Up

When you hear the phrase "involved in a cover-up," you know it isn't a good thing. But the cover-up we'll be involved in is a wonderful thing. It works so well that I hope you have some old painted panels or canvases around that you don't care much for. Dig them out now so you can participate in our "Great Cover-up."

This activity involves taking that unwanted piece and covering up part of it in order to start a new piece. It's recycling at its most artistic. The layers that are covered still have their say and add richness to the finished piece.

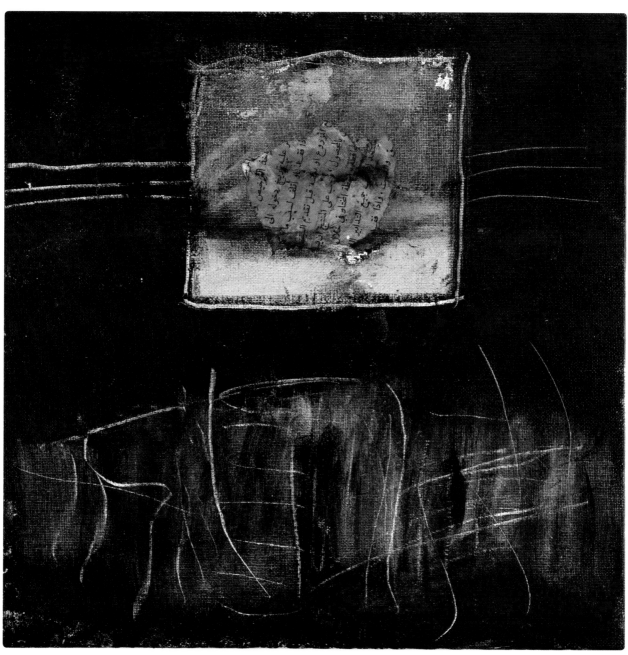

Land in View – Acrylic, re-inkers and paper on wood panel

 visit www.createmixedmedia.com/wabi-sabi for extras

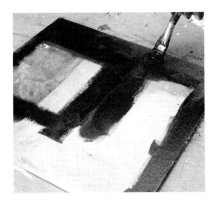

1 Start with an old painting. Mine has acrylic and re-inker on it. Spray some alcohol on the surface in random areas. Then paint black gesso over the old painting, except in the top area. That's where you'll leave a square shape.

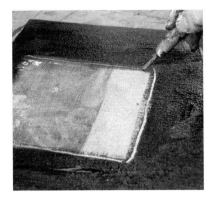

2 Incise around the square area.

3 As the gesso is drying, rub it in near the bottom of the piece so the old paint colors show through.

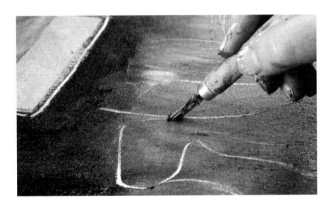

4 Incise around the bottom area, revealing light layers under the gesso.

wabi-sabi wisdom

If you don't have old panels or boards that you want to cover up, shop for old acrylic paintings at thrift stores or garage sales. Such artwork can serve as inspiring jumping-off points for a new creation.

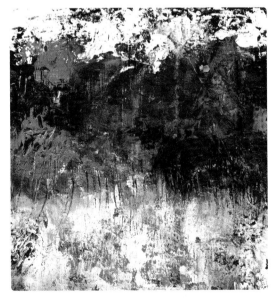

GALLERY: Bursting – Acrylic on wood panel

This piece began as the palette I used while painting another piece. I went over the paint with a few layers of color and many layers of white and Buff acrylic paint applied with a painting knife. The former palette became a vivid piece in its own right. It's a favorite of visitors to my studio. I think this piece succeeded so well because I wasn't trying—just enjoying.

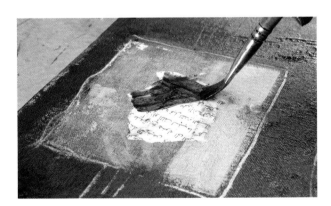

5 Tear off a small piece of vintage newspaper or book and collage it in the middle of the square. Paint red re-inker glaze over the text. Blend Caramel re-inker glaze over the square area in an uneven pattern. Finish the piece by incising a few lines to the left and right of the square.

5 abstracting from the real:
the power of suggestion

What makes children's drawings so delightful? Certainly part of the appeal is the evident joy with which they create and their lack of self-criticism, which results in lively work. I think another aspect of children's work (or is it play?) is that children tend to reduce complicated objects and people to the most essential elements. Children put down what is most important to get their visions across.

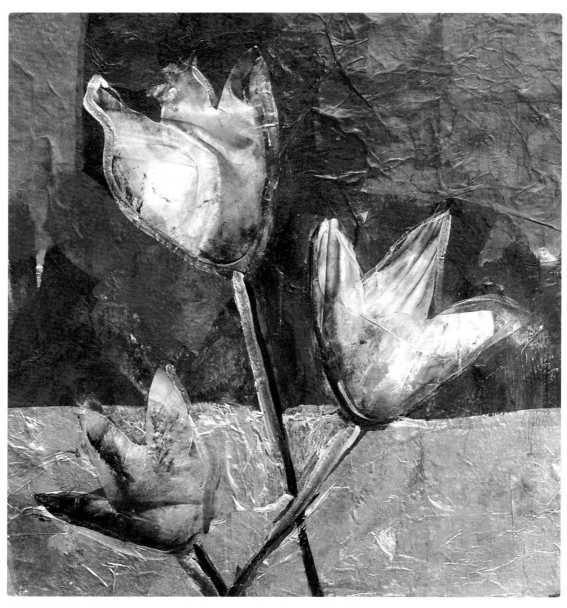

GALLERY: **South** – Tissue paper, magazine fragments and acrylic on wood panel

The term *abstract art* is often used to describe nonrepresentational art that has no basis in the external world. Abstraction may also describe art that shows the artist's ideas about what is most important in an object or person, the same way children do.

Some of the art I have created for this book doesn't represent anything in the material world, though this art may well represent emotions and thoughts. The projects in this chapter are working with abstraction a bit differently—taking the basic lines, shapes and colors of what we see and using these to represent the whole image.

When we look at the external world, our brains do some of the work, filling in blanks where our eyes can't focus or where some of the elements are missing. We do this when we look at art as well. This is why suggestion can be more powerful than minute detail. The Impressionists shocked viewers with their work, which used the effects of light to suggest rather than to spell out. People were not used to making their brains work so hard along with their eyes. About 150 years later we have no problem filling in the blanks left on the canvas by an artist who only suggests and who leaves some of the interpretation to the viewer.

Like the haiku sprinkled throughout this book, abstraction gives the potential for a large response to a minimum of suggestion. Abstraction is interactive; it allows the viewer to project his or her own ideas, feelings and responses onto the art piece.

In this chapter you'll create a collage that is an abstraction of the real, and then we'll move on to an even more abstracted painting. Abstractions vary with the artist, so have fun creating your own versions of the following projects.

WHAT YOU'LL NEED for this chapter

Acrylic paint

Construction paper

Gel medium

Glaze medium

Paintbrushes

Pre-gessoed wood panels or canvases

Re-inkers

Stamp pad

Tissue paper

Playing with Torn Paper

I remember the day I made my first torn paper collage. I was inspired by some accidentally stained tissue paper I'd found at a discount art supply store and by the hydrangeas in my backyard. Tearing the paper was very freeing and fun. I soon discovered that the staining on the tissue paper allowed me to create effects of light and shadow. That paper is long gone, alas, so now I create light and shadow with different shades of the same color.

SEEK ON HIGH BARE TRAILS
SKY-REFLECTING VIOLETS …
MOUNTAIN-TOP JEWELS.

~Bashō

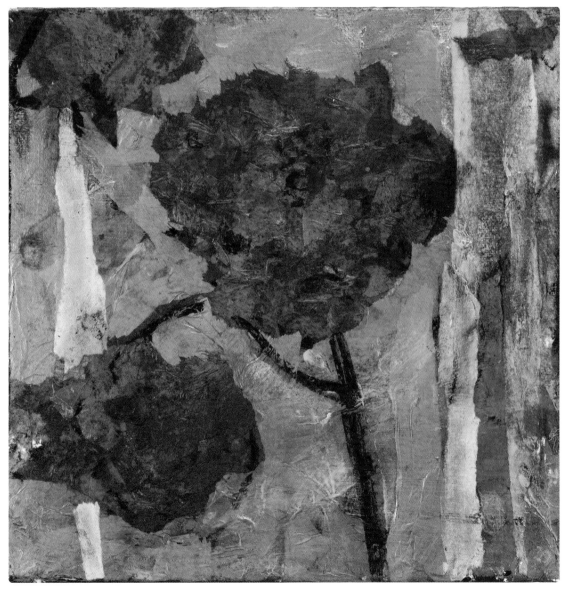

East – Tissue paper, construction paper and acrylic on wood panel

visit www.createmixedmedia.com/wabi-sabi for extras

1 Use several pieces of tissue paper to cover a wood panel. Put another color of tissue paper vertically on the right side of the panel.

2 Tear small pieces of dark pink and magenta tissue paper. Collage pieces in an abstract style to represent hydrangeas. Vary the colors to represent light and shadow.

3 Paint metallic gold acrylic over the background. Paint around the flowers and the stripe at right.

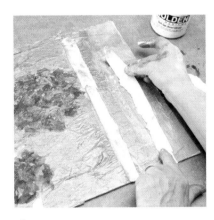

4 Tear three narrow strips of construction paper. Collage one on the left and two on the right.

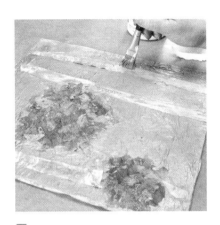

5 Rub some acrylic paint and gel medium into the yellow strips for added color.

A few final steps to unify this project:

- With dark paint, add stems on the two flowers in the foreground.
- Add the dark paint in small areas of the flowers to enhance shadows, as desired.
- Rub a little of the dark paint into the gold stripe and the purple tissue area on the right.
- Add touches of the metallic gold paint to the same area.
- Add two of the magenta tissue pieces on the far right of the piece.

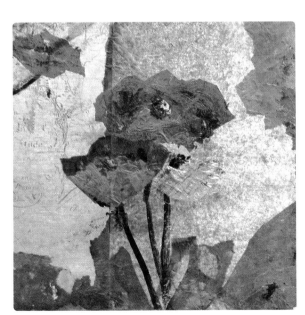

GALLERY: West – Tissue paper, wallpaper sample and acrylic on wood panel

This piece also uses a simplified, abstracted version of flowers against a variegated background.

A Brush with Abstraction

Put on some catchy music and cut loose with the next project. It's my experience that abstract pieces are best done by an artist who's been boogying around the studio, singing at the top of her lungs. Remember, it's impossible to do this technique wrong. If you don't like it, scrape it off or cover it over. It's all about the process.

IN MY OLD HOME
WHICH I FORSOOK, THE CHERRIES
ARE IN BLOOM.
~Issa

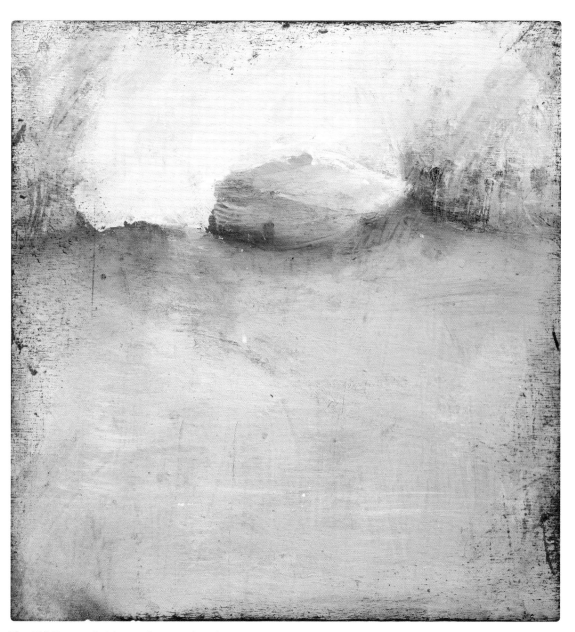

The Old House – Re-inker, acrylic on wood panel

1 Start with a pre-gessoed panel, canvas or board. Mix Green re-inker with white acrylic paint and apply it to the bottom three-quarters of the panel. Wipe the paint in. Then paint green re-inker mixed with glaze medium on both sides of the upper quarter of the piece.

2 With a wide brush, paint two wide oblong swatches of Yellow Ochre acrylic paint in the center of the upper part of the piece.

3 Lighten the upper oblong area with white acrylic paint mixed with gel medium.

4 With crimson acrylic paint and a narrow brush, make a thin line under the oblongs and over to the green area on the left. Add a little crimson paint to the right of the oblong area.

5 Mix a little of the crimson paint with white paint. Paint above and around the oblong areas between the green areas.

6 With dark acrylic paint, add a small square in the center of the lower oblong.

7 Add a thin wash of green under the oblong and under the top oblong on the right.

8 Add a thin wash of crimson paint over the large green area. Blot any excess.

wabi-sabi wisdom

An important part of creating your piece is knowing when to take a break. You can get so caught up in making your piece good that you do too much. Have a cup of tea and put your piece where you can get a good look at it from a distance. Sip your tea and contemplate your work. The piece will tell you what it needs or if it is complete. It also helps to have a supportive friend yell, "Stop!" when you are about to go too far.

9 Tap a brown ink pad on the edges of the piece. Rub a little of the ink onto the top and bottom corners of the surface of the piece for an aged effect.

wabi-sabi wisdom

Here's a fun and effective way to get inspiration for an abstract piece: You'll need an old magazine and scissors. Cut into the center of a stack of pages and cut out small squares or oblongs. Go through these images and pick out the ones that appeal to you, whether it's the color or design or some other aspect. Choose your favorite as the impetus for your piece.

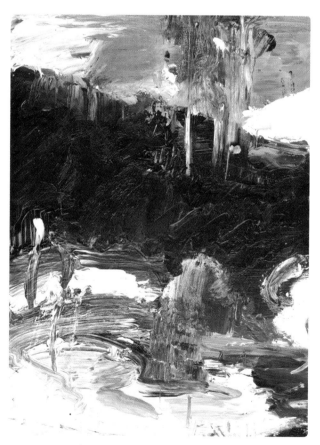

GALLERY: Winter Riches – Acrylic on wood panel

I made this piece using a random oblong piece from a magazine for inspiration. I started with the general shapes and colors from the magazine fragment. I then went on to develop my own intuitive version of the original design.

Composition Tips for Abstract Work

When I was first relearning to make art, I found that working with color was fairly intuitive for me—not so with composition. I had to learn some essential concepts before I could compose intuitively. Here are a few that helped me the most, particularly when working with abstraction:

- Tear your papers and images rather than cutting them all out neatly.
- Use color, texture and shape to create subtle repetition in your design.
- Leave simple places for the eye to rest, especially when you have a busier design. (I know, I said this before, but it bears repeating.)
- If you create an abstraction of an object, make sure it doesn't float in space (unless that is your intention). A suggestion of a surface or space that holds up the object is all you need.

Below you'll find some common composition styles. Often a piece will have more than one, but this is a good tool to start looking at composition in your work and in other artwork you observe. These images show some of the pieces in this book converted to black and white for ease of viewing the compositional lines and shapes. I've chosen some composition styles that tend to be pleasing to the eye. I often like to combine compositions; for instance, I might add a few vertical lines to a landscape piece.

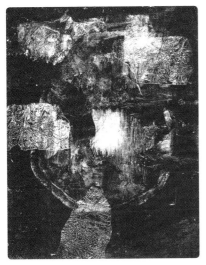

Movement of Time – Circle

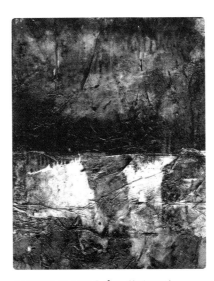

Autumn at Lost Lake – Horizontal

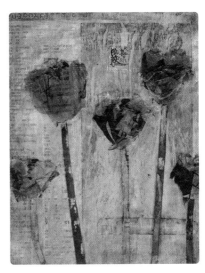

Zeitgeist – Vertical

Last Resort – Pyramid

Aftermath – Diagonal

6 translucence:
creating wabi-sabi in wax

I wax poetic when it comes to talking about working with a mixture of melted beeswax and damar resin, which is called *encaustic*. This medium is unlike any other. Encaustic layers become instantly firm, yet the pieces can be reworked any time, even years later. In this chapter, I'll demonstrate how to make encaustic medium with a simple method you can replicate in your studio or art area. When you add a colorant to the medium, you make encaustic paint. I'll show you several ways to make this delicious paint: with oil paints, oil pastels and powdered pigment.

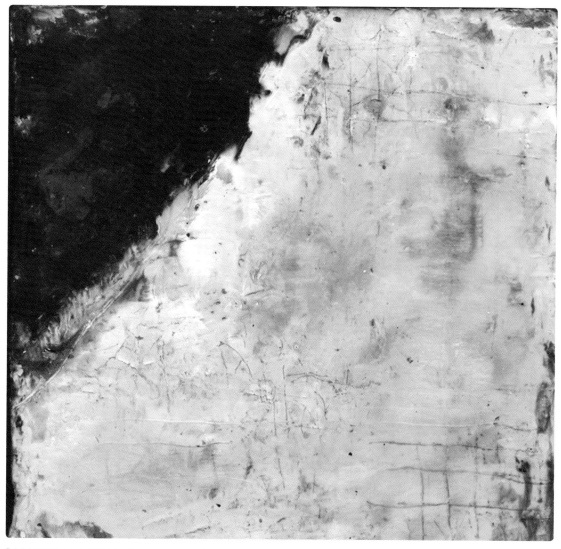

GALLERY: Last Resort – Encaustic on wood panel

The translucent qualities of the wax medium and wax paint create depth, mystery and complexity. Encaustic works shine with a natural glow, especially when you buff them. An old nylon stocking makes a great buffing tool.

You can purchase yellow beeswax, which is unfiltered and retains its natural color, or you can try filtered beeswax, which is clearer. Try both kinds to see which you prefer, or for which of your projects each kind of wax is best suited.

It's pretty easy to learn the basics of working with encaustic medium and paint. After you learn to make the medium and paint, you can spend the rest of your life happily playing with variations on the encaustic theme.

Students often ask me if they need to worry about their finished encaustic work melting. Unless you leave a piece in a very hot car for a few days, as I once did, or unless your house is on fire, you don't need to worry. You don't want to leave your pieces in freezing temperatures either, of course. Otherwise, encaustic works are very strong. We know this because we have wonderful examples of the first known encaustic works, done in ancient times by Greco-Roman Egyptians. They created beautiful, lifelike portraits of people who had died. (If you are interested in seeing these, check out Fayum portraits online.)

Fusing each layer of encaustic medium to the support or to the previous layer is an essential part of building up your encaustic work. You need to fuse each layer or stroke of paint. You can use an embossing gun, a heat gun or my favorite, a propane or butane torch.

When working with encaustic you want to have some cross ventilation in your work area and a small fire extinguisher nearby, just in case. Observe the basic precautions and you'll be fine. In fact, there's a good chance you'll fall madly in love with the encaustic process and the smell of beeswax.

WHAT YOU'LL NEED for this chapter

Bone folder

Bristle brushes

Cat food or tuna tins

Collage papers

Damar resin crystals

Electric griddle

Electric skillet

Embossing gun, heat gun
or propane or butane torch

Encaustic iron

Hot Sticks in two colors

Oil paint, oil pastels, powdered
pigments and/or premade
encaustic paint

Pottery scraper

Respirator or mask

Wood panels

Making and Applying Encaustic Medium

Getting started in encaustic is fairly easy. To make the clear medium you need an electric skillet (that you'll never cook in again), beeswax and damar resin crystals. That's all. You'll be amazed at how quickly the medium cools on your wood panel—you'll quickly be ready to fuse and apply the next layer.

Tip: Make sure your skillet's temperature control is in good working order. You want to keep the temperature no higher than 200° F or 93° C. If your medium starts to smoke, turn down the heat.

Encaustic Essentials
Clockwise from top left: damar resin crystals, unfiltered beeswax, filtered beeswax.

1 Melt damar resin and beeswax in an electric skillet in a ratio of about one part resin to six parts beeswax.

2 When the resin and beeswax are melted, apply this medium to a wood support with a wide bristle brush. Brush in one direction, one layer at a time.

3 Using a propane or butane torch, or an embossing or heat gun, heat the painted area in a back-and-forth motion to fuse the medium to the support. When the fused wax layer cools, repeat the process three more times, allowing the wax to cool for a couple of minutes after you apply it to your panel and fusing.

 visit www.createmixedmedia.com/wabi-sabi for extras

Making Encaustic Paint

In addition to buying premade encaustic paint, you can add color to your encaustic medium in several ways. Adding old broken pastels is a good choice if you have a lot of them around. I have a bunch of old oil paints that I'm using up. Powdered pigments can be expensive as an initial investment, but they are very economical in the long run.

Method 1
Add oil paint to the medium (which is kept in a liquid state in a tin on an electric pancake griddle). Put a small amount of paint in a small tin and add the clear medium. Stir until blended.

Method 2
Dip your brush in the encaustic medium and then into the pigment. Carefully add the powdered pigment to the medium. Wear a respirator or mask to avoid breathing in the pigment powder. Stir the powder and medium mixture. (Doing this in an area with good ventilation is also recommended.)

Method 3
Use premade paint. Melt it in a tin, adding clear medium if you'd like the color to be more translucent.

Method 4
Add some of your old broken pastels to the clear medium and stir occasionally as the pastels melt.

Painting Wabi-Sabi Encaustic

In this project, you'll create a visual tribute to the wonderful translucence of wax medium. Feel free to explore, add, scrape back and otherwise interact with the smooth and rich layers. You may want to try this project several times with different color combinations each time. I've chosen a simple palette for the project so you can see how interesting the wax medium and paint are on their own.

APRIL'S AIR STIRS IN

WILLOW-LEAVES ...

A BUTTERFLY FLOATS AND BALANCES.

~Bashō

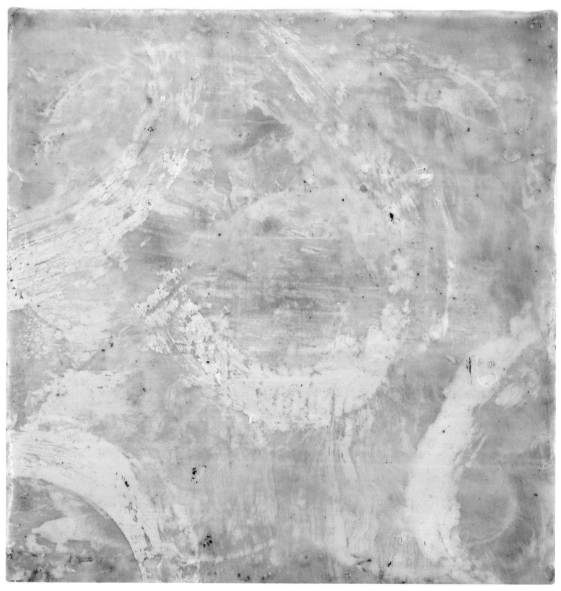

Properties of Light – Encaustic on wood panel

1 Apply and fuse three layers of encaustic medium.

2 Brush on a layer of transparent yellow-gold encaustic paint and fuse. When brushing on the paint, make some of your strokes horizontal and some vertical. Vary the size of the brushstrokes. Fuse.

3 Brush on two large oblong shapes of very transparent Ultramarine Blue encaustic paint. Add encaustic medium over the blue areas and fuse.

4 Add another layer of the yellow-gold encaustic paint and fuse. Add a layer of encaustic medium and fuse.

5 Make several half circles with opaque light yellow encaustic paint and fuse.

6 Brush a wide strip of translucent yellow paint near the bottom of the piece. Fuse.

wabi-sabi wisdom

- Regular acrylic gesso is not suitable for encaustic work, as it isn't absorbent enough. Use an ungessoed board, or try these excellent products:

R&F Paints Encaustic Gesso gives you a bright white base layer and makes a smooth surface for your wax layers.

Ampersand Encausticbord is a panel that comes with a special gesso already applied to it.

- Remember to fuse each time you put paint down. I know I keep saying this, but it's easy to forget when you are fired up with inspiration!

- If you decide you don't like the look of something you've put down, use your pottery scraper to remove it and start again. Used gently, the scraper will also smooth the surface of your piece.

- It will take some experimenting with the torch or embossing gun to discover the various effects that are possible. Be open to surprises.

- You don't have to fuse the whole piece if you have only worked in one area. Just fuse the new area.

- You don't have to put down a layer of clear medium after each painted layer, but you might choose to do this to get the effect of depth.

7 Lightly brush on clear encaustic medium over the half circles. This will make them recede, adding a sense of depth to the piece. Fuse.

8 Use your pottery scraper to scrape away any excess wax and to reveal a bit of previous layers.

9 Paint the half circles again with opaque yellow encaustic paint. The previous half circles will still show and will appear to be behind the new ones. Fuse.

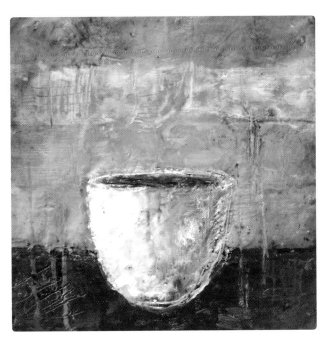

wabi-sabi wisdom

I find that several symbols often emerge in my work. You may notice that I favor cups and containers, abstract ships, mountains and water. What images recur in your work? You can always return to your symbols when you need inspiration, as there are infinite ways to use the same symbol depending on your mood and materials available.

GALLERY: Always Full – Encaustic on wood panel

This piece features one of my favorite symbols, the cup. I deliberately let some of the encaustic paint drip down the front of the piece and used incising for a weathered effect.

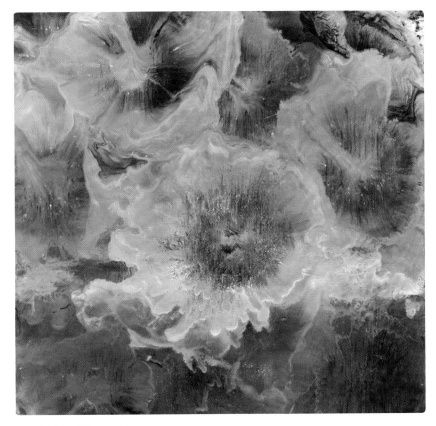

GALLERY: Bloom – Encaustic on wood panel

I used an embossing gun to blow the wax around and create shapes that suggest flowers.

Adding Collage Elements to Wax

I love collaging with wax. No glue needed. The wax serves as the glue and the sealer, and your collage elements become part of the layering of wax. You can do a straightforward collage and then apply encaustic, or use collage and encaustic paint together, layer by layer. I especially like to collage paper elements into different layers of wax, so some look closer to the surface than others. In the following project you'll use some hand-decorated papers and collage papers and a natural yellow beeswax to make a piece that soars.

IN THE TWILIGHT RAIN

THESE BRILLIANT-HUED HIBISCUS …

A LOVELY SUNSET.

~Bashō

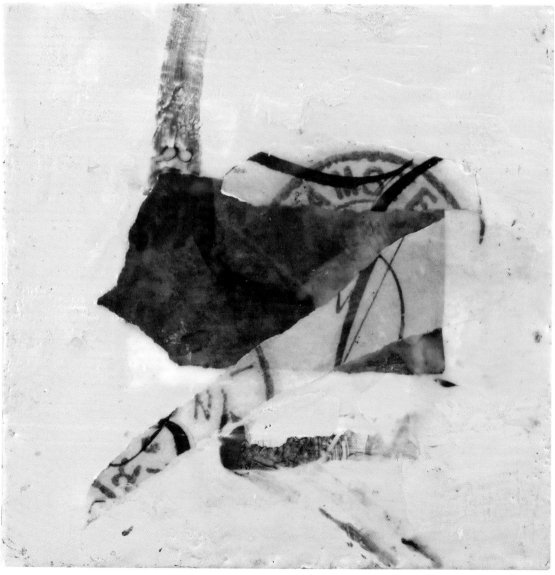

Take Flight – Encaustic and paper on wood panel

1 Brush on two coats of clear encaustic medium. Fuse after each coat. Put on a layer of Naples Yellow encaustic paint. Fuse.

2 Tear a piece of flexible collage paper. Hold it at one end and dip the rest in the encaustic medium.

3 Place the paper onto the piece. Add clear encaustic medium over the paper to keep it in place.

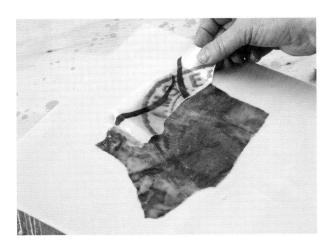

4 Tear two strips of flexible collage paper. Using the previous method, attach these pieces to the support. Fuse.

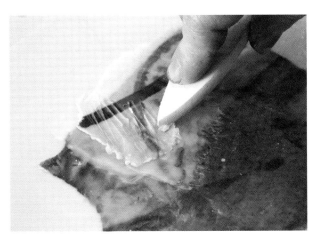

5 Burnish the paper down with a bone folder or brush handle to make sure it's flat. Fuse.

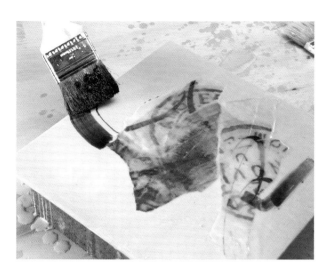

6 Brush transparent gray encaustic paint in three places. Fuse.

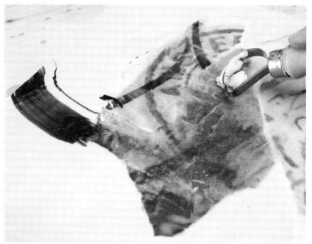

7 Scrape off a bit of the gray placed toward the bottom of the piece, using a pottery scraper.

wabi-sabi wisdom

• You can make encaustic medium in large batches so you don't have to mix the medium so frequently. Take a few hours to make lots of medium and pour the liquid into muffin tins. Pop out cakes of medium as needed.

• Lightweight papers work best in encaustic collages. If you can find old onionskin typing paper, use this in your printer to create encaustic-friendly images.

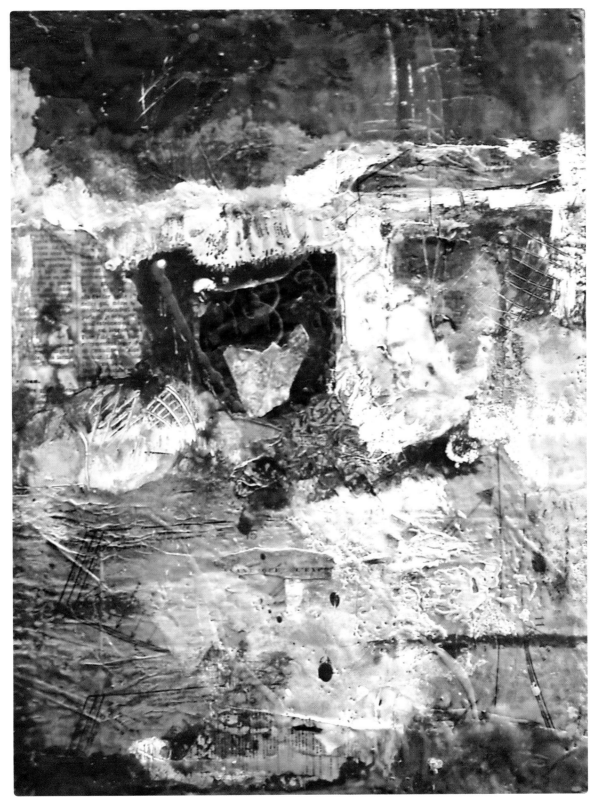

GALLERY: Palimpsest – Encaustic and mixed media on wood panel

Palimpsests are areas in a painting where layers previously covered show through. I used many different papers in this encaustic collage to suggest a wall covered with peeling paint, billboards and notices.

Hot Sticks and an Iron

I've found that I can achieve simple and elegant effects with a couple of Hot Sticks (made by Enkaustikos) and a special encaustic iron. You can find many kinds of craft irons that will work for fusing your encaustic pieces: Quilting irons, mini craft irons and sealing irons all work well. The encaustic iron I used in the *Triptych* project, at right, is larger than the other irons I've listed here. Try several irons and see which you like best.

I've never before revealed how easy this project is. Do try this at home! Choose two Hot Sticks in colors you love and iron away.

IN THE DARK GARDEN
OF THE NIGHT,
THE PEONY REMAINS QUIET ...
~Shirao

Triptych – Encaustic on wood panel

1 Put down two or three layers of clear encaustic medium, fusing between each layer. Then put a layer of white encaustic paint over the panel and fuse.

2 Melt the tip of a Hot Stick by rubbing it on your encaustic iron.

3 Quickly run the iron over the bottom of the painting in a random pattern.

4 Wipe excess wax off your encaustic iron.

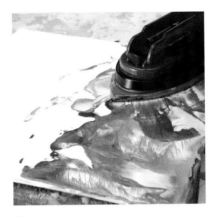

5 Repeat the painting process in step 3 with a different colored Hot Stick and your iron.

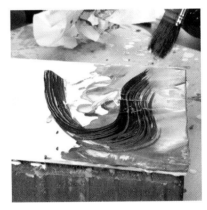

6 Dip a bristle brush into black encaustic paint and make a random design near the center of the piece. Fuse.

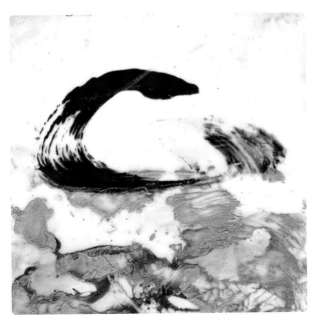

GALLERY: Spring to Life – Encaustic on wood panel

This is another simple piece with a big punch. I melted a Hot Stick on the encaustic iron and fused the wax with the encaustic iron. I repeated the process with an oil bar, which provided the iridescent effect.

7 buried treasure: 3-D wax art and other enhancements

When you add 3-D elements to encaustic pieces, you make them come alive. Before adding the embellishments, you must use papers and many paint layers to create a thick and textured piece that can hold up to the final 3-D touches. Making this kind of work is exciting—a kind of archaeological excavation in reverse. Each layer becomes a vital part of the piece. In this chapter, I'll show you how to create primal and mysterious work that invites the viewer to imagine a story woven into the piece with each layer and each element.

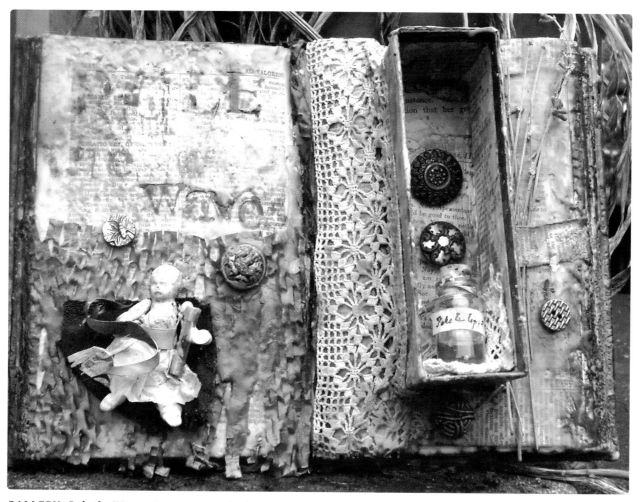

GALLERY: **Rule the Waves** – Encaustic, vintage book and mixed media

I'll show you how to add layers of wax and specialty papers and how to incise into the work to show what has come before. As you add and scrape back you'll become intimate with your material and express your deepest self. It's said that all of our art pieces are in some way self-portraits. With 3-D wax art, your capacity for expressing your own vision and voice knows no bounds!

In this chapter I'll share my excitement for hunting and gathering battered embellishments and unusual papers. In the first project you'll learn how to attach an embellishment to your encaustic piece in a way that enhances without overpowering the piece. In the second project you'll get adventurous with a vintage book, embellishments and encaustic medium. Sort through your treasures for your favorite embellishments, heat up the wax and take off!

WHAT YOU'LL NEED for this chapter

Amber shellac	Neocolor II crayons
Beeswax	Oil paint
Bristle brushes	Old newspaper
Carving tool	Paper towels
Cheesecloth	Pottery scraper
Craft knife	Rubber stamp and pad
Damar resin	Small metal embellishments
Dark twine	Tissue paper
Faux metal flakes	Vegetable oil
Gold transfer foil	Vintage books
Heat gun, embossing gun or torch	Wood panels
Lightweight collage paper	

Hunting and Gathering Embellishments

I love the thrill of the hunt; that is, chasing down weathered and fascinating objects to put in my art. I frequent garage sales when the weather is nice. I stay inspired in the winter by visiting my local antiques mall. And, of course, etsy.com is a continual source of delight and cool stuff. Here are some pictures of my stash to inspire you.

Embellishment Drawers
I found this homemade cabinet at a secondhand store. Intended for storing small electrical parts, there were still a few left in some of the drawers. This is a perfect place for my bits and bobs.

Vintage Paper Display
This metal box, another thrift-store find, holds a display of vintage papers, letters, sheet music and books, hand-decorated paper and specialty papers. Just looking at this cornucopia gives me a mixed-media buzz!

Treasure Trove

I've strewn the top of a garage-sale bookcase with inspiring items from my stash. These include my Frozen Charlotte doll collections, carved and papier-mâché hands, my great grandmother's purse, a vintage doll head and a tarnished silver dish filled with fish vertebrae.

Vintage Rubber Stamp Display

This vintage stamp set is an antique mall find. I love the old-style letters, numbers and symbols. I use these stamps frequently in mixed-media work to give a sense of eras gone by.

Curio Cabinet

I've filled other shelves of my garage-sale bookcase with more special treasures. My buttons repose in my grandmother's pink ice bucket. The shelves also hold old button cards, vintage photos, altered books and bunches of costume jewelry. This cabinet puts me in a creative mood as soon as I enter the studio.

Tea Bag Collection

Deliciously stained used tea bags sit in a handmade box. I use these tea bags frequently in mixed-media art and I also just like to look at them.

Attaching an Embellishment

The metal pieces in my work are integral elements and not just things I stuck on as an afterthought. In this project, you'll use twine and a circular piece of vintage metal to create a dream world that evokes peace and joy. The twine literally and metaphorically attaches the metal in an organic way.

TEMPLE BELLS DIE OUT.

THE FRAGRANT BLOSSOMS REMAIN.

A PERFECT EVENING!

~Bashō

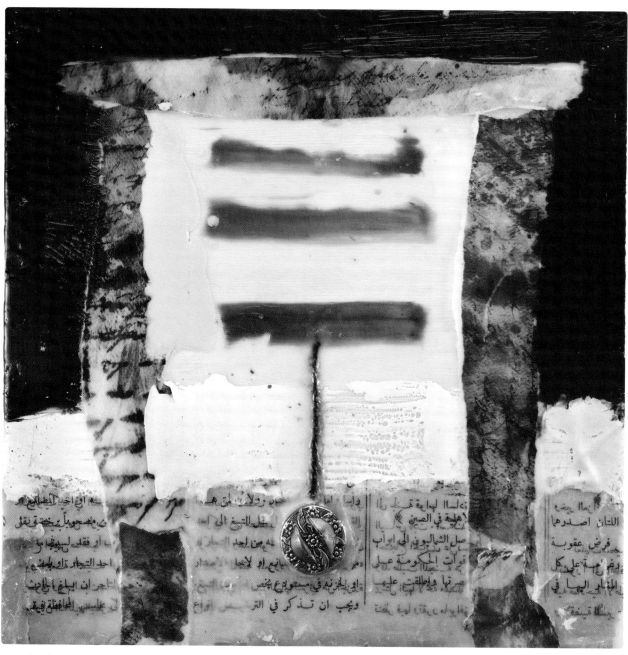

Temple – Encaustic, collage papers, twine and embellishment on wood panel

1 After applying and fusing four layers of encaustic medium to a wood panel, tear a strip from an old newspaper and collage it to the bottom of the panel with encaustic medium.

2 Paint a strip of Celadon encaustic paint above the newspaper. Fuse.

3 Paint three horizontal stripes with brownish red encaustic paint in the center of the piece. Fuse.

4 Use the pottery scraper to vary the edges of the stripes by removing a little of each stripe.

5 Tear three strips of lightweight collage paper. Collage one on either side of the red strips and one above. Fuse.

6 Paint around the collaged strips above the Celadon area with black encaustic paint and fuse.

7 Dip a piece of twine into the encaustic medium and collage it from the lowest red strip to just below the Celadon area. Fuse gently.

8 Brush encaustic medium on the back of a round piece of vintage metal.

9 Attach the metal to the piece.

10 Brush encaustic medium around the metal piece and fuse. Repeat two or three times until the metal is firmly in place.

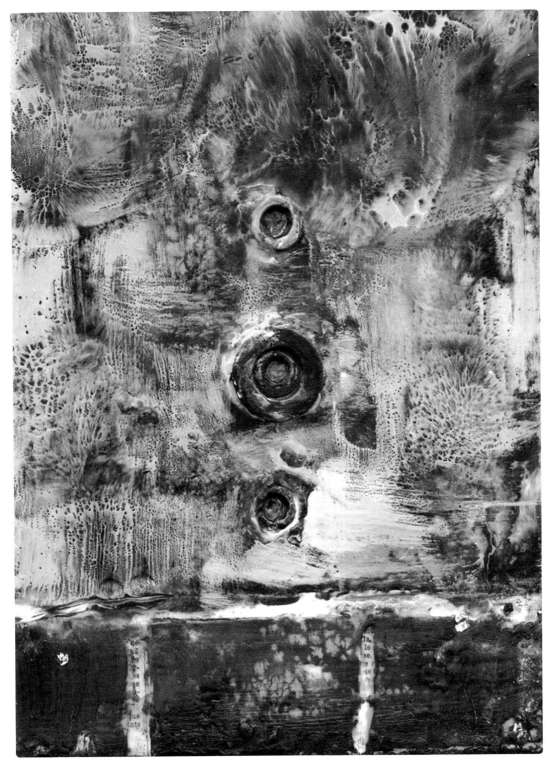

GALLERY: Freighter – Encaustic on wood panel

This piece is painted on a surface that is actually an old oil painting. In the areas inside the metal rings, I built up enough encaustic layers to be able to then dig deeply into the wax and expose the original painting.

Embedding in a Niche

You can embed a 3-D item in layers and layers of wax on your wood support. In this project, you'll be doing something more outrageous and fun: embedding your 3-D embellishment in a waxed book. You should know that an addiction to wax can create a desire to wax everything in sight. A while back I had another *what if* day and decided to wax some vintage books to create encaustic assemblages full of special treasures. That's what we're going to do now, so dip into your stash of old books for one that is ripe for transformation.

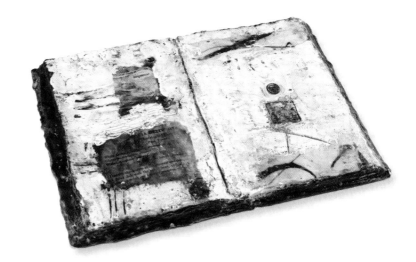

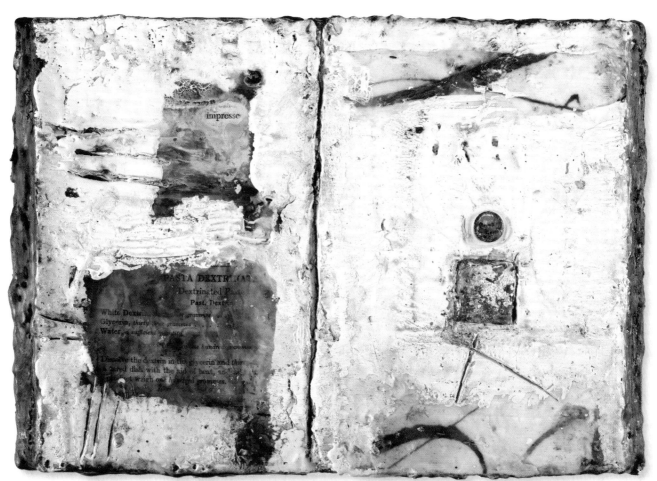

Swifts – Encaustic, paper and found objects on vintage book

1 With a craft knife, cut out a section of the book on the right side. This should be the size, shape and depth of the object you are going to embed.

2 Coat the front and sides of the book with encaustic medium. Fuse.

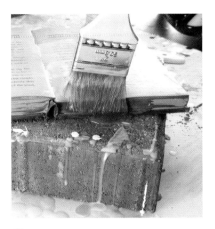

3 Add another coat of encaustic to the front and sides of the book and fuse again.

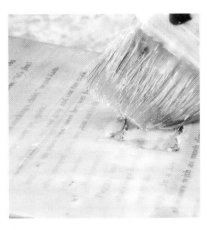

4 Brush encaustic medium on the inside of the niche.

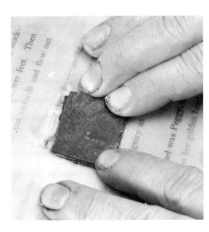

5 Press your object into the niche.

6 Paint two or more layers of Celadon encaustic paint around the object. Fuse between layers.

7 On the left side of the book, brush on a layer of Burnt Sienna encaustic paint. Fuse.

8 Paint over the Sienna paint layer with a layer of dark brown encaustic paint. Fuse.

9 Paint a layer of Celadon encaustic paint over the dark brown layer. Extend the paint into the center area between the pages. Fuse.

10 Using a pottery scraper, scrape back the upper area of the left page, creating a square area through which some of the Dark Sienna and a little of the book text show through.

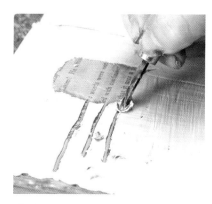

11 Use a carving tool to incise three deep lines to the left of the scraped-away square.

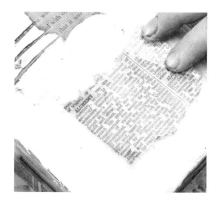

12 Under the square, use encaustic medium to collage an oblong piece of text from another book. Fuse gently.

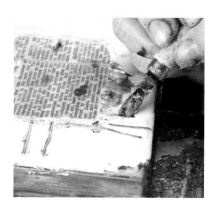

13 With the carving tool, incise two lines to the left of the text piece and three lines below.

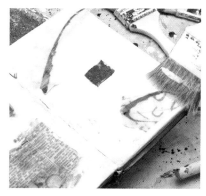

14 Tear two pieces of collage paper with a simple black-and-white design. Collage one near the top of the right page and one at the bottom of the page. Fuse.

15 Brush encaustic medium over the niched object. Press faux metal flakes into the object so they stick. Fuse gently.

16 Incise the outline of the object with your carving tool. Incise two overlapping lines below the object.

17 Take an old pin or button with a sharp shank on the back. Press it into the wax above the embedded object. Paint around the edges of the pin with Celadon encaustic paint.

18 With your carving tool, incise deeply into the center between the two pages.

19 Highlight around the collaged areas with a light brushing of black encaustic paint. Fuse.

20 Brush black encaustic paint over the edges of the book pages. Fuse.

GALLERY: Demeter Wept – Encaustic, metal, plant material, ceramic figure, netting, ink, rusted mesh and raffia on vintage book

I was inspired by the myth of Demeter and Persephone when I made this piece. The piece has a lot of layers of wax with vintage paper embedded in several of the layers. Though it is dense, the overall composition is fairly simple.

Incising a Focal Point

You've done some incising in a few of your previous projects. For this project, incising will be the focal point of the piece. And you'll use oil paint to bring out the drama of the incised area.

Your inspiration will be the legend of a ghost ship, endlessly sailing. The project I did was actually inspired by the wreck of a ship along a coast over the mountains from where I live. The ship ran aground in 1906, and, fortunately, everyone on board survived. The romantic wreck is still there, surrounded by playing children and lounging adults.

AMONG THE GRASSES
OF PASSING AUTUMN,
THE STREAM HIDES ITSELF.
~*Shirao*

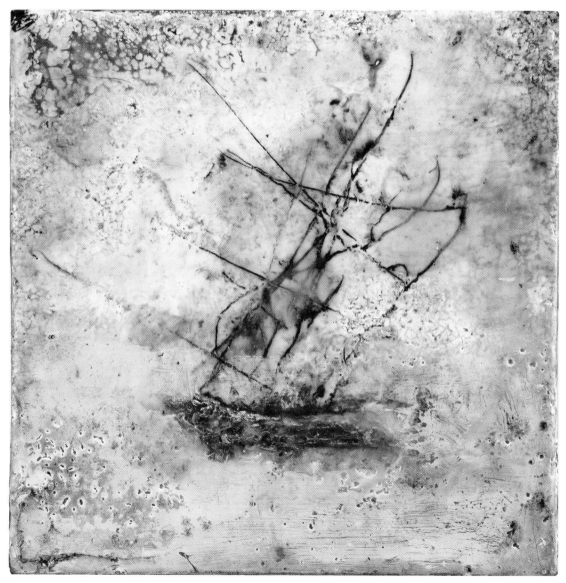

Ghost Ship – Encaustic, tissue paper, cheesecloth, shellac and oil paint on wood panel

1 After applying and fusing three layers of encaustic medium, paint on two layers of white encaustic paint. Fuse each layer. Then create a free-form design in the wax with a sharp carving tool.

2 Rub black oil paint into the incised areas. Make sure all of the incisions are filled with paint.

3 Rub off the excess black oil paint with a paper towel.

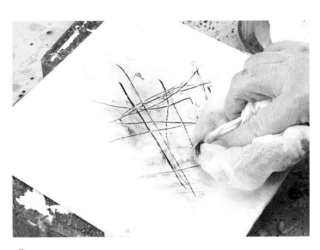

4 Dip a paper towel or shop towel in vegetable oil and finish picking up the excess paint.

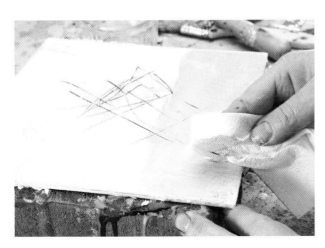

5 Rub in some Naples Yellow oil paint and fuse.

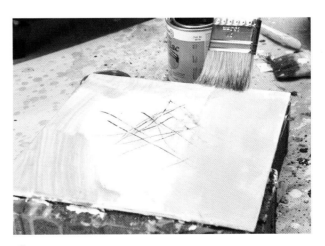

6 Paint amber-colored shellac around the edges of the piece.

7 Fuse the shellac areas with a butane or propane torch. (It will flame briefly, so make sure there are no flammable items nearby.)

8 Collage a little off-white tissue paper or a bit of cheesecloth around the middle of the piece to suggest a ship. Fuse.

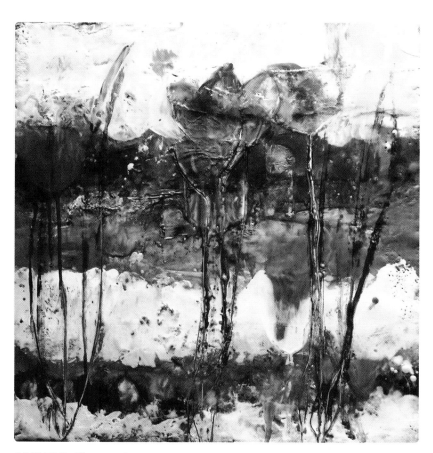

GALLERY: Flowers Encaustic paint on wood panel

I incised flower stems and leaves and rubbed Burnt Umber oil paint into the incisions. This painting is also a cover-up—it was originally an encaustic landscape I wasn't thrilled with. I added the off-white encaustic paint and incised several areas to create this abstract flower piece.

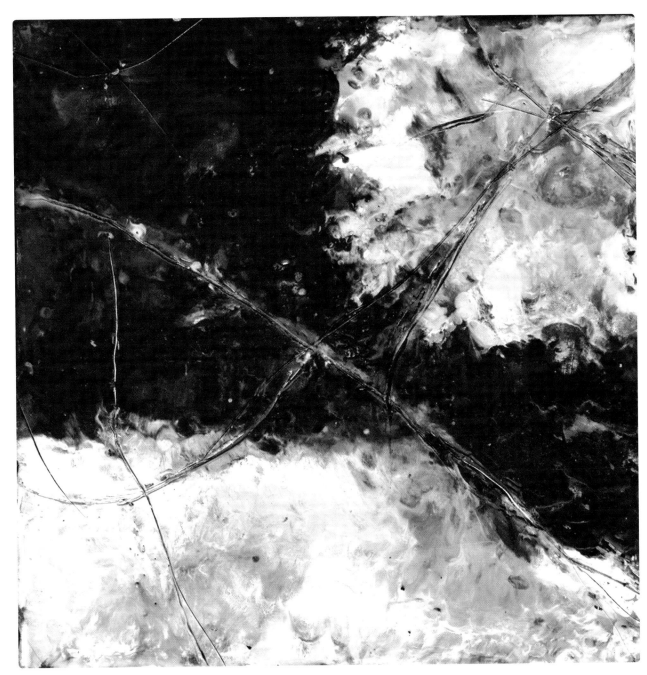

GALLERY: Signs of Aging – Encaustic paint on wood panel

This piece was inspired by a photo in a book on painting restoration. The book was full of close-up photos of problem areas in paintings in need of restoration. I found these photos beautiful and fascinating. The inspiration photo showed deep cracks in an old master painting. Incising into wax yielded a similar fascinating effect.

Oil Paint with Wax

Oil paint can be used in many ways to enhance your encaustic pieces. I sometimes rub a bit of a dark oil paint into the corners of my pieces to give an aged look. You can brush or rub oil paint over your encaustic piece and then fuse the oil paint so it becomes part of the wax layer. This can give a subtler and even more transparent effect than using a layer of encaustic medium.

In this project, you will rub on oil paint and incise into the layers to create drawings. You can't help but have fun with this technique. I titled this piece *Cebolla and Friends,* as *cebolla* is Spanish for *onion.* I just love how the word sounds, and I love to draw onions. Grab one from the kitchen if you need a model.

STILLNESS:

SINKING INTO THE ROCKS—BUT STILL

A CRICKET'S VOICE.

~Bashō

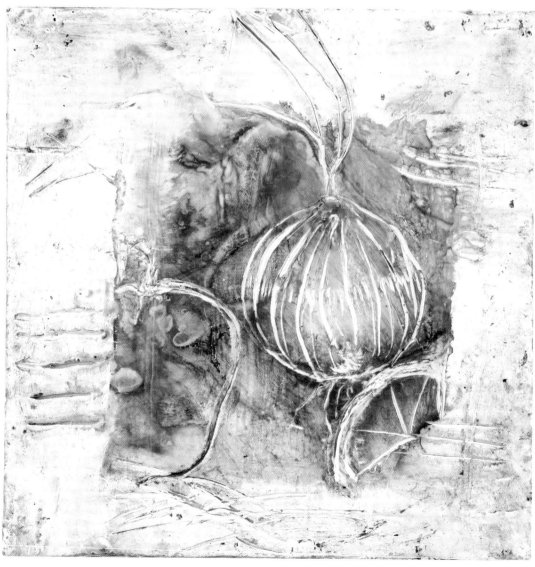

Cebolla and Friends – Encaustic and oil paint on wood panel

1 Brush three layers of encaustic medium onto a wood panel, fusing between layers. Rub transparent Azo Green oil paint into the wax surface, removing extra paint with a paper or shop towel. Fuse lightly.

2 Rub in a layer of Crimson Brown in the same way and fuse. Then use your torch or embossing gun to move the oil paint around the panel in roughly circular forms.

3 Brush opaque white encaustic paint over the oil paint, leaving a large area in the center uncovered. Fuse the white paint, allowing some of the background to come through.

4 While the wax is still a little soft, incise designs and lines into the white area of the piece. Doing so allows some of the previous layers to emerge in the design.

5 Using a carving tool, incise an onion design into the center area, allowing the stem you incise to go into the white area at the top of the piece. Carve the outline of an apple and part of a sliced orange into the center area on either side of the onion design.

6 Rub Crimson Brown oil paint lightly into some of the incised lines of the onion and the fruit. Fuse lightly.

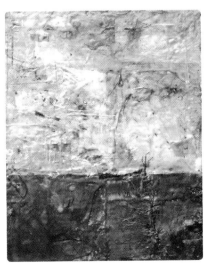

GALLERY: Shipwreck – Encaustic, paper, oil paint and fabric on cradled wood panel

Here I painted Burnt Sienna oil paint onto the bottom of the piece and fused it. I then rubbed a bit of the oil paint into the upper area of the piece. The oil paint combined with the wax creates a rich, translucent area of color. I placed a small piece of fabric above the oil-painted area and teased out a few bits of the weave to suggest the wreckage of a ship.

Gold Transfer Foil with Wax

You'll love using transfer foil with encaustic! You can use just about any tool you have handy to transfer the foil to your piece. The foil cheerfully embeds itself in the wax with ease.

In this project, you're going to use transfer foil sparingly but to great effect.

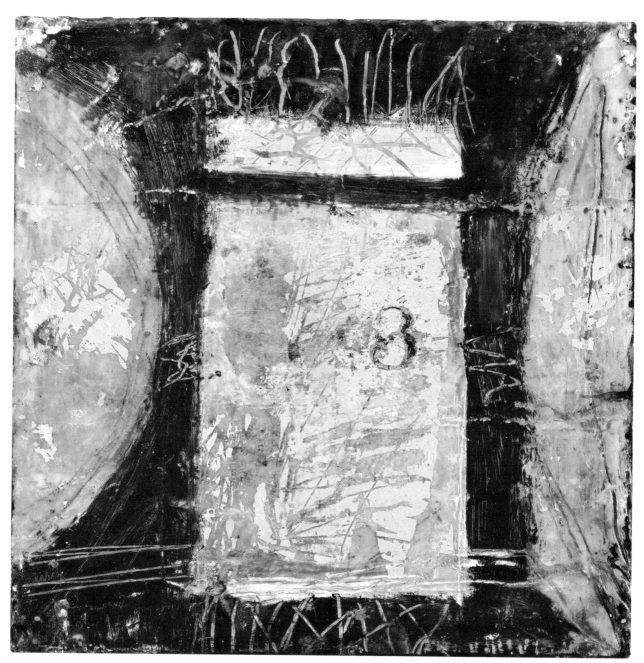

Three – Encaustic paint, Neocolor II crayons, gold transfer foil and oil paint on wood panel

visit www.createmixedmedia.com/wabi-sabi for extras

1 Apply and fuse two or three clear layers, and then paint on and fuse an off-white layer of encaustic paint.

2 Paint on three Yellow Ochre areas with encaustic paint: one half circle on the left edge of the board, an oblong area in the middle and another half circle along the right edge. Fuse.

3 Color over the Ochre areas with red and gold Neocolor II crayons. Outline the Ochre areas with the red crayon.

4 Add accents with a turquoise Neocolor II crayon. Smudge.

5 Rub the gold transfer foil into the Yellow Ochre areas.

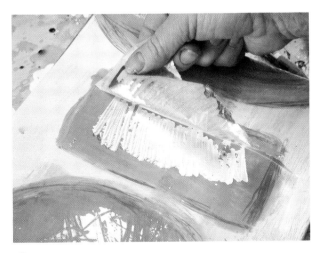

6 Pull the backing paper off the foil to reveal.

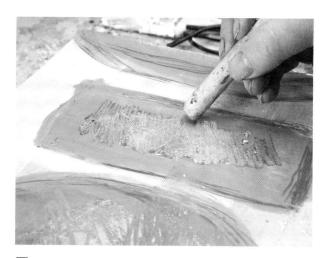

7 Press down any loose foil with the wooden end of a carving tool or a similar tool.

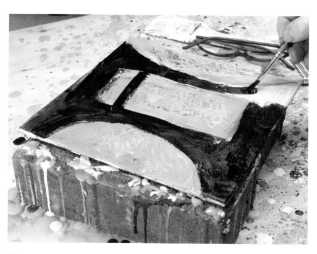

8 Paint around the Ochre area with black oil paint. Fuse the entire surface with an embossing gun. (The oil paint will still take a while to dry.)

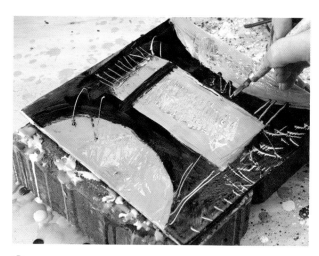

9 Incise designs into the black area with a carving tool.

10 Stamp into the center Ochre section with a rubber stamp and ink.

SPREADING A STRAW MAT IN THE FIELD

I SAT AND GAZED

AT PLUM BLOSSOMS.

~Buson

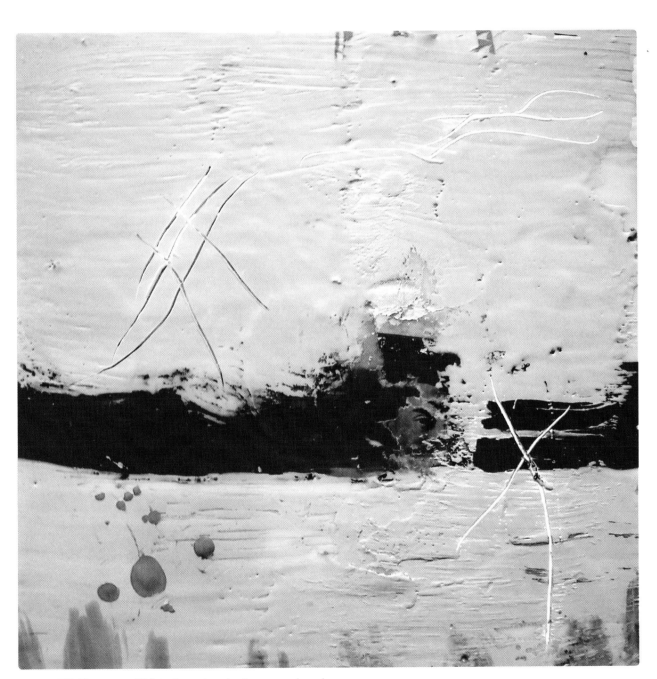

GALLERY: Thames at Night – Encaustic and collage on wood panel

This piece has just a touch of collage and a touch of gold transfer foil. I added three areas of incising and filled them with white oil paint.

continuing with wabi-sabi

ON ALL SIDES,
THE PEONY WARDS OFF
RAIN CLOUDS.
~Buson

The projects and inspirational photos in this book have added much awareness and joy to my life. I'm honored to share these with you and I envision you adding your own inspirational photos and developing your own style as you continue in the wabi-sabi way.

I continue to take my wabi-sabi walks frequently. Even when I think I must have exhausted the possibilities for inspiration around my neighborhood, I always find more. I hope you, too, will continue to enjoy this relaxing and creative way of participating more fully in the world around you.

You may decide to keep a wabi-sabi journal of poetry, colors, textures and your own writing. This journal can be your companion in your daily life, offering inspiration that keeps your creativity fresh.

Thank you for taking this journey with me!

~Serena

dedication

To Dot, with more love and gratitude than I can express. To my children, Karuna and Ian, and my grandson, Dexter, for being yourselves, to my stepfather, Rob, for his continued support, to my brother, Spencer, for a lifetime of laughing together, and to Ruby, Jackie and Susie for being the best of out-laws.

To the memory of my parents, who would have been so proud.

acknowledgments

Thanks to my dear friends and students who have encouraged and cheered me every step of the way. You are all in the parade, and I've learned so much from you.

Thanks to the amazing team at North Light, including Tonia Jenny, who first supported this book. Thanks to Kristy Conlin, my wonderful editor, and Christine Polomsky, photographer extraordinaire, both of whom made the photo shoot a delight. Thanks to book designer Julie Barnett, production coordinator Greg Nock and all the others who made this book a reality. Thanks for a dream come true.

Resources

I'm lucky to live in a town that has several independent art stores. I know this isn't always the case for artists, so I want to share with you some of the excellent online resources that I also enjoy using.

PAINTING SUPPLIES AND PANELS
www.dickblick.com
www.jerrysartarama.com
www.cheapjoesartsupplies.com
www.utrechtart.com
www.danielsmith.com

ENCAUSTIC SUPPLIES
www.encausticpaints.com
www.evansencaustics.com
www.rfpaints.com
www.swanscandles.com

AMATE AND OTHER SPECIALTY PAPERS
www.dickblick.com
www.amazon.com

RE-INKERS AND ALCOHOL INKS
www.blockheadstamps.com

ORGANIZATIONS AND SITES
www.international-encaustic-artists.org
www.creativeclearinghouse.com
creativeworkshops.ning.com
www.flickr.com (This site has several wabi-sabi groups.)

ART RETREATS
www.artandsoulretreat.com
www.art-is-you.com
www.artunraveled.com
www.createmixedmediaretreat.com

BOOKS ON WABI-SABI
Wabi-sabi by Mark Reibstein and Ed Young (Little, Brown Books for Young Readers)

Wabi-Sabi: for Artists, Designers, Poets & Philosophers by Leonard Koren (Imperfect Publishing)

Wabi-sabi: The Art of Everyday Life by Diane Durston (Storey Publishing)

Wabi-sabi: The Japanese Art of Impermanence by Andrew Juniper (Tuttle Publishing)

also by Serena Barton

A Joyful Frenzy (available from blurb.com)

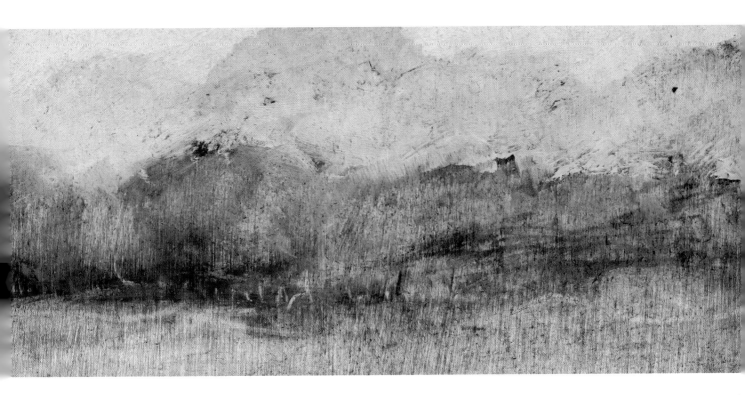

index

about the author

Visual art was Serena's first love as a child. She moved on to acting in local plays and later became a licensed professional counselor. Serena rediscovered her desire to make art following her first trip to Italy. She taught herself to paint and create mixed-media work in midlife, proving it's never too late to create!

Serena holds creativity and art workshops, and groups and individual art coaching at her studio and at national art retreats. She exhibits and sells her work through galleries and shops, as well as online. Serena has published *A Joyful Frenzy*, a book of her artwork with text on the stories and processes behind the work. Serena's magazine articles have appeared in issues of *Cloth Paper Scissors* magazine and *Studios* magazines and in *Cloth Paper Scissors* e-Books.

Serena's great joy is to provide an atmosphere in which you can discover or rekindle your own creative abilities. She lives in Portland, Oregon with her partner and near her children and grandchild. She loves hanging out with family and friends, and is an avid reader.

Visit Serena's website, www.serenabarton.com, and her blog, serenabartonsblog.blogspot.com.

COPYRIGHT INFORMATION

17 16 15 14 13 5 4 3

Distributed in Canada by Fraser Direct
100 Armstrong Avenue
Georgetown, ON, Canada L7G 5S4
Tel: (905) 877-4411

Distributed in the U.K. and Europe by F&W MEDIA INTERNATIONAL
Brunel House LTD, Newton Abbot, Devon, TQ12 4PU, ENGLAND
Tel: (+44) 1626 323200, Fax: (+44) 1626 323319
Email: enquiries@fwmedia.com

Distributed in Australia by Capricorn Link
P.O. Box 704, S. Windsor NSW, 2756 Australia
Tel: 02 4560 1600
Fax: 02 4577 5288
Email: books@capricornlink.com.au

ISBN-13: 978-1-4403-2100-9

www.fwmedia.com

Edited by KRISTY CONLIN

Designed by JULIE BARNETT

Photography by CHRISTINE POLOMSKY

Production Coordinated by GREG NOCK

looking for more wabi-sabi inspiration?

We have tons of FREE **Wabi-Sabi Art Workshop** companion content to inspire you! Have a smartphone with a QR code reader? Just scan the code to the left (or go to www.createmixedmedia.com/wabi-sabi) for access to painting and encaustic technique tutorials and embellished paper demos.

These and other fine north light mixed media products are available from your local art and craft retailer, bookstore and favorite online supplier. Visit our website at **createmixedmedia.com**. Find the latest issues of *Cloth Paper Scissors* magazine on newsstands or visit **shop.clothpaperscissors.com**.

createmixedmedia.com

• Connect with your favorite artists.

• Get the latest in mixed media inspiration, instruction, tips, techniques and events.

• Be the first to get special deals on the products you need to improve your mixed media endeavors.